IMAGES
*of America*

# GARNER

IMAGES
*of America*

# GARNER

Kaye Buffaloe Whaley

ARCADIA

Published by Arcadia Publishing
an imprint of Tempus Publishing Inc.
Charleston SC, Chicago, Portsmouth NH, San Francisco

Printed in Great Britain

Library of Congress Catalog Card Number: 2003111780

For all general information contact Arcadia Publishing at:
Telephone 843-853-2070
Fax 843-853-0044
E-mail sales@arcadiapublishing.com
For customer service and orders:
Toll-Free 1-888-313-2665

Visit us on the internet at http://www.arcadiapublishing.com

*To my husband, Ron, my sons Rod (daughter-in-law, Cheryl) and Bill, whose encouragement, love, patience, and understanding allowed me to attempt this endeavor.*

# CONTENTS

# ACKNOWLEDGMENTS

This work is made up of contributions by past and present citizens of Garner and its surrounding communities; they have shared their family and local history along with pictures since 1968. The book is a culmination of resources that have all been invaluable in the preparation and completion of this project. My attempt to give honorable mention to everyone is without perfection, thus any exclusion is accidental and is not meant to diminish the efforts of any participants. Sincerest thanks to Lucile Bryan Stevens, a fellow Garner native with roots extending back in the early 1800s, whose endless contributions and friendship I am eternally grateful. My thanks to Robert "Bobby" Creech, also a Garner native with a lineage dating back to the mid-1800s, who has been extremely considerate. His memory and beneficence was exemplary. I would also like to express my earnest appreciation to all the contributors, citing their endless generosity and their respect for their communities: Ann Phillips Holland and Sandra Morris Wall, from the Ebenezer community; Rebecca Lane Payne, Walter H. Stallings, and Jean Watts Wiltsey, from the Auburn community. In regard to modern technology, this feat could not have been accomplished without Craig Jarman and his computer expertise. Thanks also to Cheryl Whaley (my daughter-in-law) for her editing assistance. I would like to recognize my publisher; I am forever indebted to Maggie Tiller and Laura New for their interest and guidance, which made this book possible.

# INTRODUCTION

Saint Mary's (formerly known as St. Maries), Panther Branch, and Swift Creek townships are located southeast of Raleigh in Wake County, situated in the eastern piedmont of North Carolina. In 1771, Wake County was named for Margaret Wake, wife of Royal Governor William Tryon, and was formed from Johnston, Cumberland, and Orange Counties.

Below are several individuals that came from Virginia to North Carolina in the 1700s, received land grants, were successful planters, and were very active in the county and state governments:

Robert Whitaker received his first land grant of 800 acres from King George II in 1741. He built his house about 1743 (now Saint Mary's township), and his son, Col. John Whitaker, was born there in 1745. Colonel Whitaker received several land grants, was a Revolutionary War patriot, served as justice of the court in Wake County from 1777 to 1787, a member of the Wake County Governing Board, representative to the Council of Safety, and a road commissioner for Wake County. He was a successful planter and owned and operated a tannery, brickyard, lumber mill, and turpentine and pitch distillery. The house is located on its original site and has been restored.

John Rand came to North Carolina in the 1760s and bought land on both sides of Swift Creek (now Saint Mary's and Panther Branch townships) and operated Rand's Mill and a tavern. He was a practicing attorney as well as a delegate to the August 1775 and 1776 Provincial Congresses. In November 1777, a special election was held and John Rand was elected to represent Wake County in the House of Commons. He was killed during the Revolutionary War in 1781, leaving a wife and daughter. The family legend is that a neighbor, who was a Tory, killed him. John Rand bequeathed to his brother, Walter Rand, the land and plantation on which he lived. Walter Rand came to Wake County in 1783 after serving in the Revolutionary War in Virginia. He served as a state representative to the legislature in 1806.

Matthew McCullers, from the Panther Branch township, served as a state representative to the legislature in 1800–1801.

The Saint Maries district tax list of 1819 listed about 85 landowners; the Panther Branch district tax list of 1814 listed about 80 landowners; and the 1817 tax list of Swift Creek listed about 60 landowners.

On July 11, 1851, the groundbreaking for the North Carolina Railroad took place east of Wake County. It was completed in 1856. The railroad right-of-way maps from the 1850s show the tracks passing through several farms of what is now Garner, including those of Barnabas

Johnson, A. Bagwell, and James and Keziah Olive Dupree. A "wood and water stop" was located in this area for the train.

Saint Mary's, Panther Branch, and Swift Creek townships felt the effects of the Civil War. Husbands and sons had been called to fight for the Confederacy and had it not been for the large number of slaves, many women would have found it almost impossible to manage the farms and raise the food supplies required for the armies as well as the household.

Henry Fort, a former slave on the William L. Fort farm, bought 52.25 acres for $1,040 from Eli Dupree on December 23, 1874, adjoining the North Carolina Railroad near the "wood and water stop." He was a black cabinetmaker of wardrobes, bureaus, and other pieces of furniture as well as a farmer. Henry Fort died in the late summer or fall of 1876.

In 1878, the area succeeded in getting a post office established. The name given was "Garner Station" and it was located near the "wood and water stop." (Extensive research has been done on how Garner was named; however, the source remains unknown.)

On March 6, 1883, by an act of the General Assembly, Garner's Station was incorporated. The corporate limits were as follows: 200 yards, each way, from T.W. Bennett's store. In 1891, Garner's Station's incorporation was repealed.

In 1895, H.D. Rand moved his mercantile business from Rand's Mill to Railroad Street at Garner Station. Many farmers were coming to the Village of Garner, buying a lot, and building a new house for their family, yet they continued to operate their farms in the county. The population in 1896 was 250 and there were four general stores and one drugstore.

In 1902, the Garner Depot, a four-room, tin-roofed building, was constructed for passenger service and freight shipments and deliveries. When freight was received at the depot, recipients were notified by postcard and were allowed three days for pick-up. Garner was a well-known cotton market when "cotton was king." The North Carolina Railroad built a large platform adjacent to the depot and in the fall cotton buyers would arrive to buy cotton from the local farmers. In the early 1900s, for a fee of 10¢, one could ride the train one way into Raleigh, leaving at 8 a.m. or 4 p.m. and expect to return at 11 a.m. or 8 p.m.

In 1905, Garner was incorporated under the name of the Town of Garner. The corporate limits were: one-half mile east and west, one-quarter mile north and south from the center of the well at Rand's Store.

The Bank of Garner opened in 1910 but closed during the Great Depression. Telephone service came to Garner in 1912 and the switchboard was installed in the home of Mrs. Vera Jones. Old Garner Road, as it is known today, was paved about 1916–1917. Carolina Power and Light Company received permission to construct and maintain lines for the transmission of electricity to the Town of Garner in 1925.

Farming was the chief source of income for the local people and cotton was the principal crop until the 1940s–1950s, when tobacco became the principal crop. During this time period, more and more residents were leaving the farms and driving to Raleigh to work for North Carolina State University, North Carolina State Government, and other businesses or industries.

Garner continued to grow with the construction of housing developments. In the 1950s, Hilltop, Forest Hills, and Cloverdale housing developments were built; in the 1960s, Heather Hills was developed. The population in the 1950s was 1,200.

Kaye Buffaloe Whaley
March 2003

# One

# ST. MARY'S TOWNSHIP

## 1700S TO 1960S

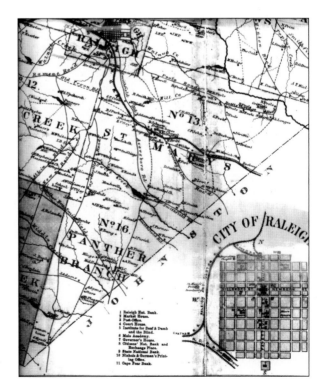

The 1879 Fendol Bevers map of Wake County included St. Mary's, Panther Branch, and Swift Creek townships and indicated the local churches, creeks, homes, mills, and roads. (Courtesy of North Carolina Department of Archives.)

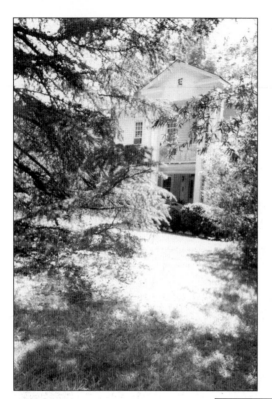

Edenwood, located on Old Stage Road (Old Fayetteville Road), was built in the mid-1700s. Sihon Smith, a Methodist minister who rode the circuit, lived in this house and was visited by Francis Asbury in 1805, as this was a stagecoach stop. Sihon Smith's daughter married into the Williams' family, recognized in the naming of Williams' Crossroads, located a couple miles east of the house.

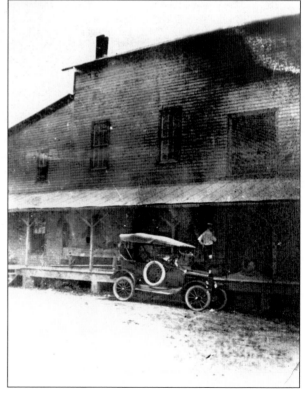

The first Rand's Mill was located on the north side of Swift Creek and was operated by John Rand until his death. Members of the Rand family continued operating a mill until the 1920s (pictured here in the 1920s), when it was destroyed by fire.

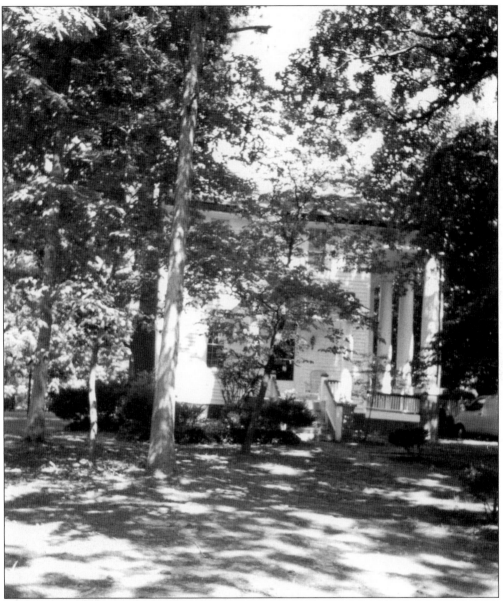

Known as the "Echo Manor Plantation House" located on Colonial Drive is Col. John Whitaker's house, built by his father, Robert Whitaker, in 1743; this is the oldest house in Wake County on its original site. Col. John Whitaker was active in the militia when it was called out to duty in 1776. He was also active in establishing the Wake County government and served on the first governing body in Wake County.

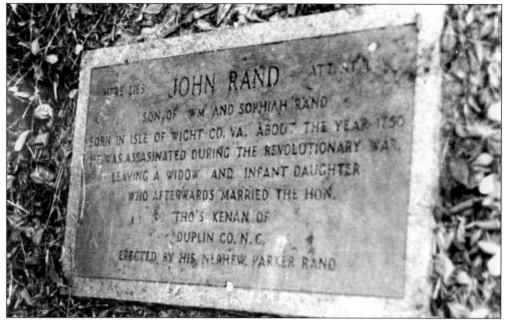

This historic marker in the Rand Cemetery, located at Highway 50 South and Buffaloe Road, honors John Rand; this early settler in Garner was a practicing attorney, a delegate in the Provincial Congress in 1775 and 1776, and represented Wake County in the House of Commons in 1777. It reads as follows: "Here Lies John Rand Att. at Law, son of Wm. and Sophiah Rand, born in Isle of Wight Co. Va. About the year 1770 he was assassinated during the Revolutionary War. Leaving a widow and infant daughter who afterwards married the Hon. Tho's Kenan of Duplin Co. N.C. Erected by his nephew, Parker Rand."

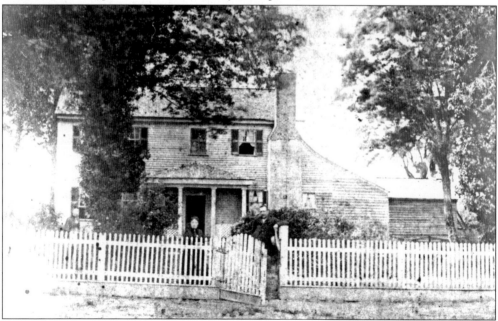

The Nathaniel Rand house was located on Buffaloe Road. The house, pictured in the late 1800s, has since been torn down. The original part of the house is a single story with a chimney.

New Bethel Baptist Church, off Highway 50 South in Garner, is seen here in the current day. The church was built on land purchased from William Rand in 1859. New Bethel Baptist Church endured the Civil War, though not unscathed; an overhead door casing sustained a bullet penetration from a Union soldier and it remains in preservation by the church.

Mt. Moriah Baptist Church was founded in 1832 as interdenominational without a minister. The initial building was a chapel constructed in 1832 on one acre of land purchased from William Dodd. A new church was built between 1912 and 1914. Lumber came from a nearby grove where church members cut down the trees and Roy Baucom hauled them to the sawmill. The church's handmade pulpit was carved by a Selma, North Carolina cabinetmaker in 1832 and the Regulator clock that hangs in the sanctuary was purchased for $7 in 1906. The "Summer House" (in the foreground) covers the well that served Mt. Moriah Academy around the turn of the century. Horses were watered here and Roy Baucom would carry buckets of water from the well to spectators at the nearby ballgames. The Summer House well has been covered and the house serves as a resting place for walkers, joggers, and bicyclists. It is maintained by Mt. Moriah Baptist Church.

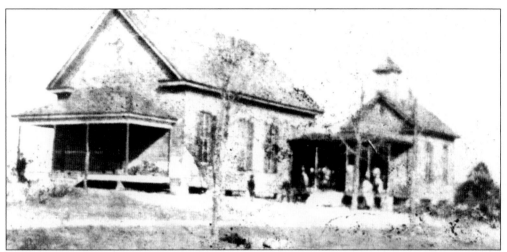

Mt. Moriah Male and Female Academy was established in 1894 across the road from Mt. Moriah Baptist Church (intersection of Old Garner Road and Rock Quarry Road) and remained opened until 1926. It is now a residence.

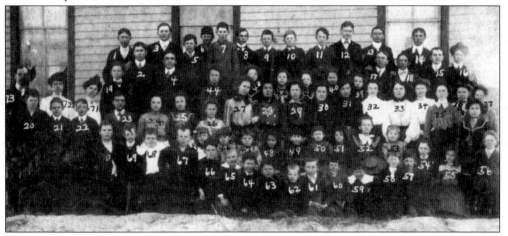

This is the 1902 Class of Mt. Moriah Male and Female Academy. Pictured are the following: 1. Edward Smith, 2. Arthur Pleasant, 3. Earl Poole, 4. ? Blackman, 5. Walter Poole, 6. Frank Poole, 7. Rom Sturdivant, 8. Clarence Johns, 9. Roy Baucom, 10. Exum Sturdivant, 11. Harry Baucom, 12. Charles Kelly, 13. ? Massengill, 14. ? Short, 15. unidentified, 16. unidentified, 17. Arthur Tillison, 18. David Avery, 19. George Baucom, 20. "Little Saw Mill Boy" Southern Savory, 21. Edwin Smith, 22. Garland Spence (Spencer), 23. Harlan Smith, 24. Ethel Ferrell, 25. Eunice Avery, 26. Myrtie Honeycutt, 27. Maud Pleasant, 28. Bessie Wall, 29. Pearl Kelly, 30. Foy Baucom, 31. Mattie Johns, 32. Ina Ferrell, 33. Lessie Barnes, 34. Eula ?, 35. Ava Poole, 36. Lucile Johns, 37. Bernice Kelly (well-known North Carolina author), 38. R. Floyd Kelly, 39. Meta Baucom, 40. Enid ?, 41. Bell Poole, 42. Maud Stallings, 43. Emma Sturdivant, 44. Eva Parrish, 45. Lillian Baucom, 46. Agnes Honeycutt, 47. Chloe Sturdivant, 48. Kate Stallings, 49. Nannie Lou Poole, 50. Elizabeth Adams, 51. Cleo ?, 52. Kitty Poole, 53. Lynda Sturdivant, 54. Veola Poole, 55. Helen Adams, 56. Elliot Poole, 57. unidentified, 58. Swain Sturdivant, 59. William Olive Kelly, 60. unidentified, 61. Milton Wall, 62. ? Wall, 63. Darwin Kelly, 64. Elwood Kelly, 65. Aaron Wall, 66. Jesse Kelly, 67. Kenneth Wall, 68. Nowell (Noel) Poole, 69. Royal Adams, 70. unidentified, and 71. Sue Kelly. (Courtesy of Walter H. Stallings.)

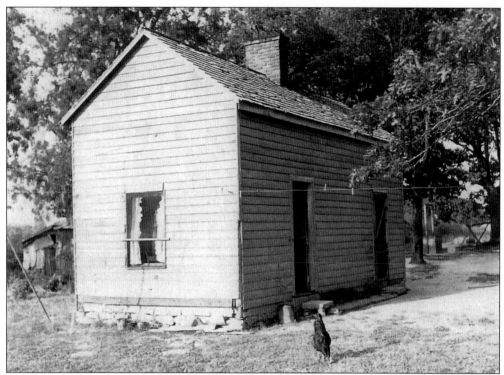

This separate kitchen/dining house, with a well to the right, was originally located on the Bert Wall farm on Rock Quarry Road. The building no longer exists. (Courtesy of Sandra Morris Wall.)

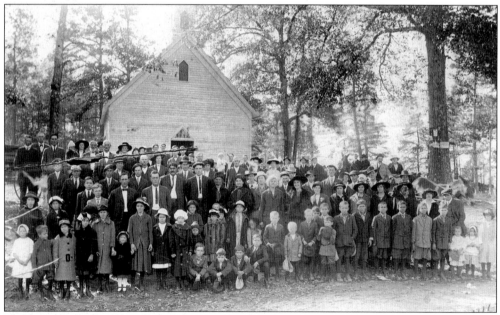

Ebenezer Methodist Church members gathered in front of their wooden chapel c. 1923. The church was organized about 1840 and is located on Rock Quarry Road. A brick church was built in 1949 following the demolition of the wooden chapel. (Courtesy of Sandra Morris Wall.)

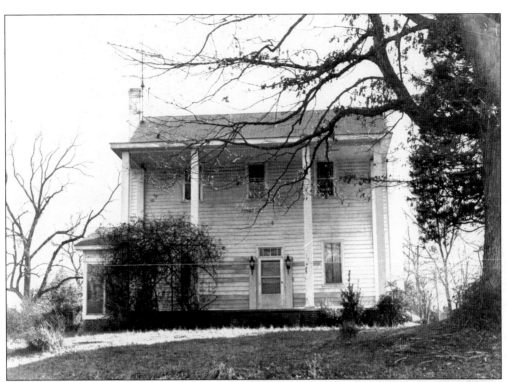

Fabius "Fab" A. Whitaker was a plantation owner of 373 acres in 1891. His house was located at Old Stage and Vandora Springs Roads. It is said that Samuel Whitaker, son of Col. John Whitaker, built the house. Colonel Whitaker served as high sheriff of Wake County during 1820–1821 and was elected nine times to the North Carolina House of Commons and five times to the North Carolina State Senate (between 1822 and 1840). (Courtesy of North Carolina Department of Archives.)

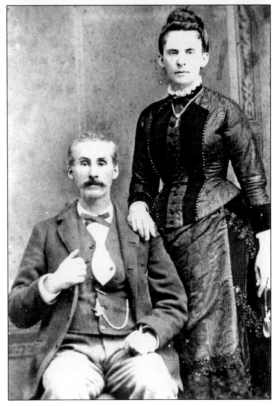

Fabius A. and Ellen W. Whitaker pose for this c. 1890s photograph.

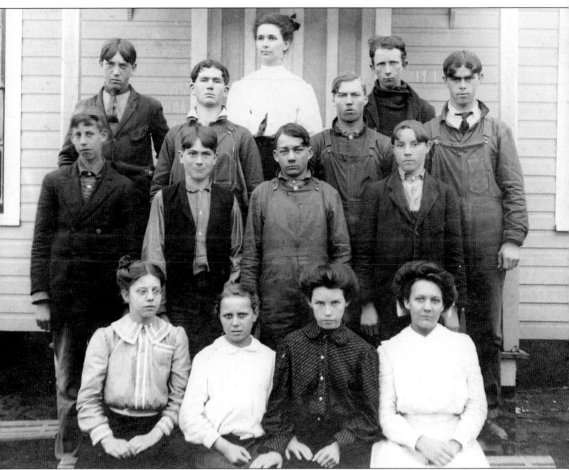

Cade Springs School, a private school, was built in the 1800s and later closed in 1926. The children then attended Mt. Auburn School. These students are listed from left to right as follows: (first row) Annie Warren, May Stanley, Mary Roach, and Martha Harris; (second row) Roy Stanley, Winden Harris, and Samburn Roach; (third row) Johnny Stanley, Tommy Ward, Cleave Harris, and Lee Roach; (fourth row) E. Warren (teacher) and Bill Jessup.

William Henry Hamilton came from England to settle in Florida but found his home in North Carolina. He became the groundskeeper for the Capital Square and was the flora culture editor for *NC Planter Magazine* from January 1858 to December 1860. He entered the War between the States in 1861 and was blinded in 1862. Later, he moved to this house on Salt Hill Road (built about 1850) and farmed.

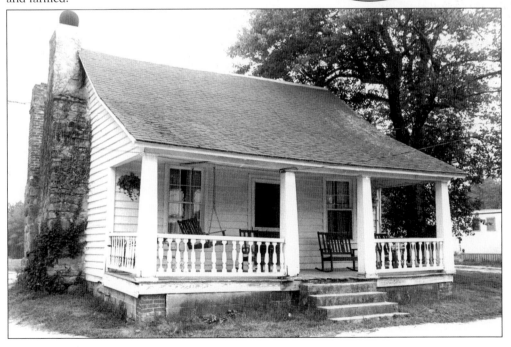

The parents of seven children, Troy and Elizabeth "Betty" Ann Rand Baucom lived on Old Baucom Road (which was Battle Bridge Road) in the Mt. Moriah community. Their plantation totaled 386 acres in 1891. Mr. Baucom, a private in the War between the States, enlisted at Camp Holmes in Wake County on October 26, 1864. Betty died in 1898 and Troy died in 1899. (Courtesy of Walter H. Stallings.)

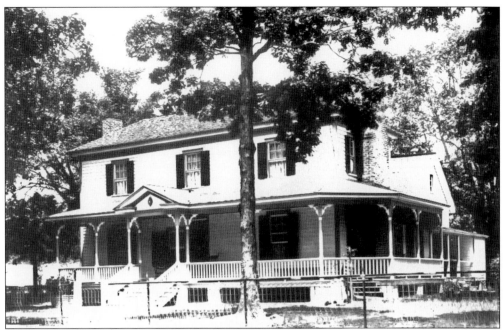

Troy Baucom and his wife lived in the single-story house in the far right of this picture (c. 1851). Additions depicted in this photo were built to accommodate the Baucom children. J. Alpheus and Adeline "Addie" Baucom Stallings (daughter of Troy Baucom) added the porch in the early 1900s. This house is located on Old Baucom Road (formerly Battle Bridge Road) in the Mt. Moriah community. (Courtesy of Walter H. Stallings.)

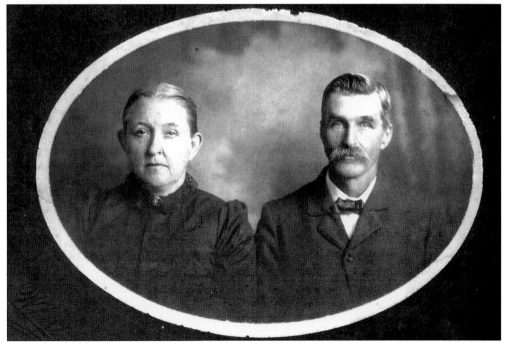

Pictured are J. Alpheus and Mary Adeline "Addie" Baucom before 1917. (Courtesy of Walter H. Stallings.)

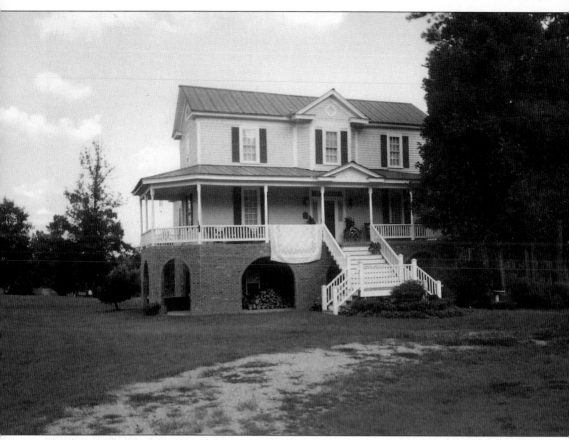

This house, built in 1910 by Walter H. Stallings's great-grandfather, J. Alpheus Stallings, and grandfather, Walter R. Stallings Sr., was moved off Old Baucom Road to its current location on Branch Road. (Courtesy of Walter H. Stallings.)

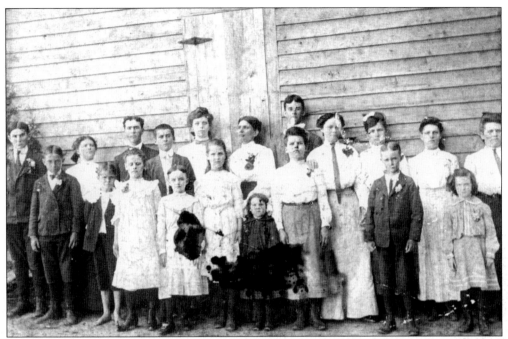

Pictured here is a group of Beulah School children about 1901. The school was located on Vandora Springs Road. Betty Smith Buffaloe is seen on the back row on the right end wearing a tie.

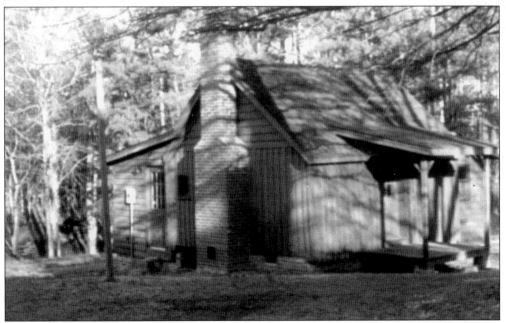

Before the War between the States, John Creech built a two-story house, which Union soldiers burned in April 1865. The Creech family moved into one of the log cabins situated on the farm. John's son Ezekiel Creech and his wife, Mary Lewis Creech, lived in one of the log cabins until 1900. Ezekiel's son James Creech and his wife, Arabelle Creech, lived in a log house built about 1880. Bobby Creech has restored the 1880 log cabin. (Courtesy of Bobby Creech.)

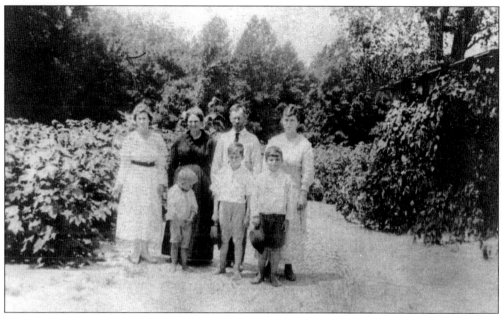

Seen in 1916, James Creech's family are identified, from left to right, as follows: (front row) Ray Creech, Kermit Creech, and Boyd Creech; (back row) Dessie Creech Pearce, Arabelle Williams Creech, James Creech, and Lillian Creech Blackburn. James and Arabelle Creech outgrew the small log house and built a house with a porch and basement. They moved into the house in the fall of 1922. Today this is the Bobby Creech house. (Courtesy of Bobby Creech.)

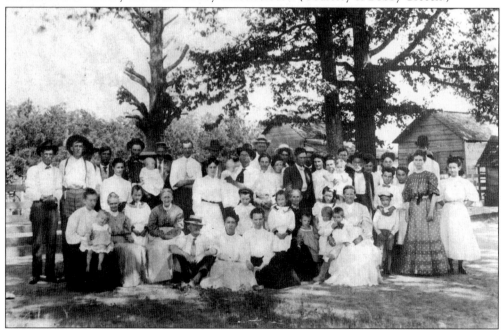

Needham and Sarah Jones Bryan had 11 children; the family has celebrated a reunion every year since about 1895. In the early years, the reunion—seen here about 1900—was held at their son's house (William's wife is Julia Penny Bryan) on Bryan Road. (Courtesy of Martha Bryan Liles.)

24

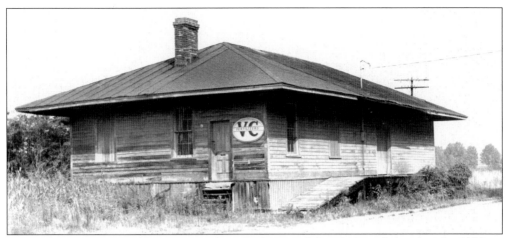

The Auburn Depot on Old Garner Road was built around the 1900s and closed in the 1950s or 1960s. Seen here in 1978, the depot was destroyed sometime thereafter. (Courtesy of North Carolina Department of Archives.)

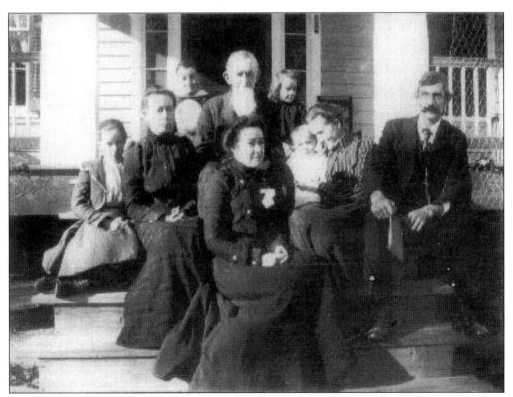

James Graham Lane was active in the Auburn community. Pictured here about 1900, these people are identified, from left to right, as follows: (front row) Anna Graham; (middle row) Bessie Evans Lane, Ella Graham, Margaret Maria Lane, Nettie Maude Graham Lane, and James Julius Lane; (back row) James Graham Lane, James Madison Graham, and Eva Lane Pool. (Courtesy of Rebecca Lane Payne.)

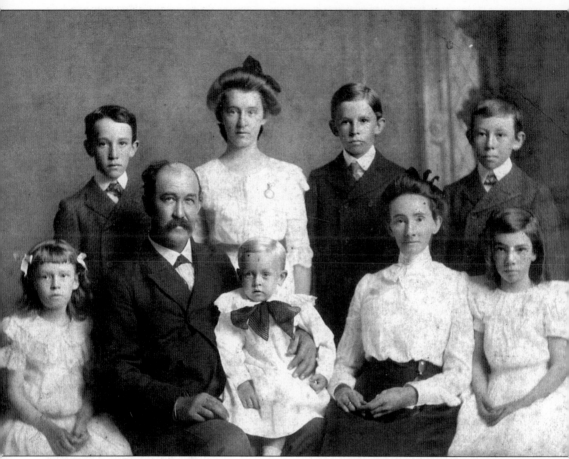

George "Urias" Baucom was a farmer and owned about 386 acres on Old Baucom Road (was Battle Bridge Road) in the Mt. Moriah community in 1891. Photographed in 1901 in Raleigh are, from left to right, the following: (front row) Lillian Irene Baucom, George "Urias" Baucom holding Troy Baucom, Lillian "Irene" Allen Baucom, and Meta Gertrude Baucom; (back row) Roy Allen Baucom, Foy Hope Baucom, George Urias Baucom Jr., and Harry Lee Baucom. Not pictured were Candice Johns Baucom, born in 1901; John Reynold Baucom, born in 1902; and Genevieve Baucom, born in 1906. Irene's father, Capt. Nick Allen, and Urias' father, Troy Baucom, were soldiers in the War between the States. (Courtesy of Walter H. Stallings.)

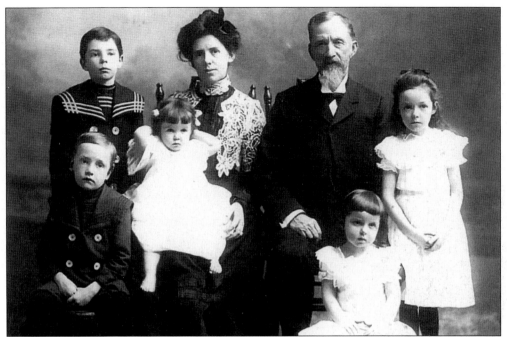

Coy Pool was a farmer and storekeeper in the Mt. Moriah community. About 1902, this photograph was made. His family lived on Brownfield Road (the house has been torn down). They are, from left to right, as follows: (front row) Glenn Pool, Winona Pool, and Bessie Pool; (back row) J. Graves Pool, Augusta Pool, J. Coy Pool, and Jessamine Pool. (Courtesy of Rebecca Lane Payne.)

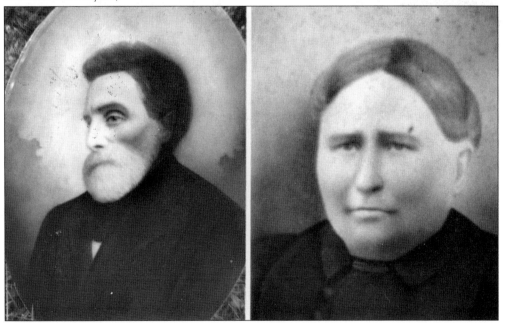

William D. Buffaloe (left) married Catherine Wilder (right); he was a soldier in the War between the States. In November 1878, he purchased 126 acres of land with a house on Buffaloe Road (now destroyed). He was a well-known cotton farmer and agriculturist.

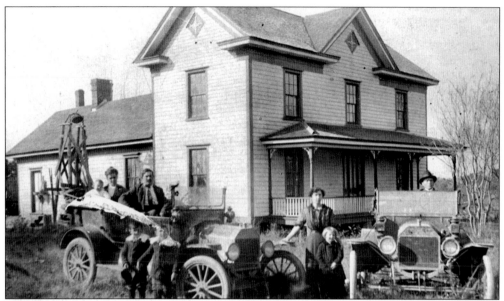

In 1918, Bryant Ralph "Rafe" Buffaloe was living in his father's home (William D. Buffaloe) on Buffaloe Road. Shown with him are, from left to right, the following: baby Vivian with her mother, Geneva Wilder Buffaloe; father, Bryant Ralph Buffaloe (in the automobile); their two sons beside the automobile, Bryant Jr. and Leonard; (standing in front of Myrtle Wilder) Ellen Buffaloe, daughter of Rafe and Geneva; and (in the automobile on the right) Burwell Burton Buffaloe, Rafe's brother. Bryant Ralph and Burwell B. Buffaloe were operating Buffaloe Brothers Co., Inc. in Garner on Main Street in 1925.

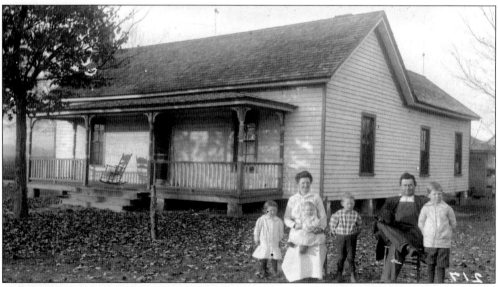

Early Buffaloe, son of William D. Buffaloe, was a cotton farmer. Pictured at their house on Old Garner Road are, from left to right, the following: Mary Lee Buffaloe, Mary Cleveland Blalock Buffaloe (Early's wife) holding Virginia Buffaloe, David Buffaloe, Early Buffaloe, and William Jackson Buffaloe. He sold the farm to the State in 1928 to be used as a school for the blind; today it serves as offices for the North Carolina State Highway Patrol and SBI. The State moved the house behind the office buildings.

Early Buffaloe is pictured here in a cornfield on his farm in Auburn around the 1930s. (Photo by a Swift & Company representative.)

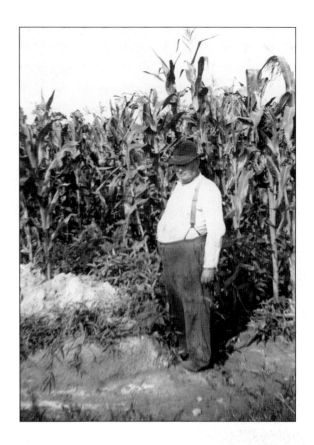

Kudzu has covered some trees on the Town of Garner's property on Rand Mill Street. In the 1880s, kudzu seeds were brought to the United States from Japan to be used as an ornamental plant. A climbing plant, it was used along porches around the 1900s, later as forage for livestock. In the 1930s and 1940s, kudzu was used for soil conservation. Very common in the South, it grows at the rate of a foot a day.

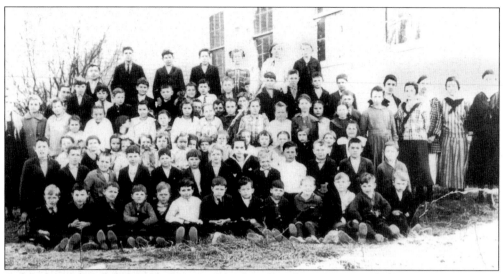

Seen *c.* 1906, Mt. Hope School on Rock Quarry Road was located near Ebenezer Methodist Church. A private school and a new schoolhouse were constructed in 1906 and later closed in 1926; the children were sent to Mt. Auburn School. (Courtesy of Sandra Morris Wall.)

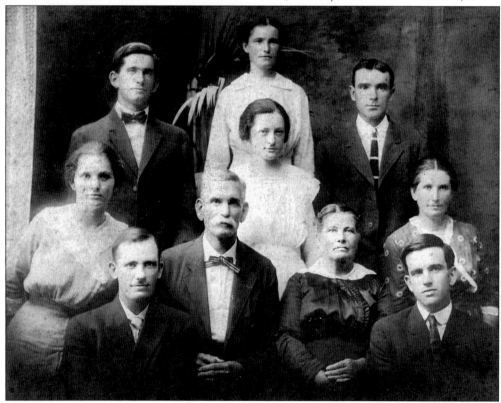

Around 1912, the Henry Watkins Miller Bagwell family gathered for this photograph. From left to right, they are (front row) May Bagwell Holder, Edgar Bagwell, Henry W. Bagwell, Fannie Bagwell, Guy Bagwell, and Dora Bagwell Brown; (back row) Walter Bagwell, Lissie Bagwell Stell, Lillie Bagwell, and Dallie Bagwell. (Courtesy of Anne Phillips Holland.)

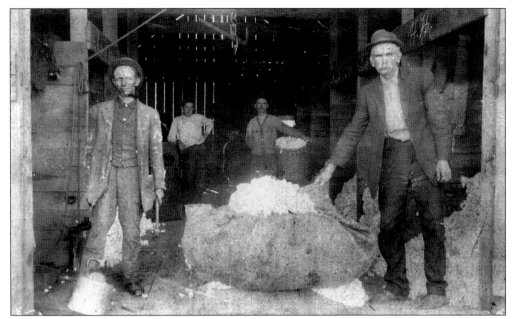

Henry Bagwell (far right) holds a burlap sheet full of cotton while inside the cotton gin. (Courtesy of Anne Phillips Holland.)

Henry W.M. Bagwell and Fannie McCadney Pool are pictured here around 1914 in the yard at their farm purchased around 1903 (known as the Berry Bagwell farm) located on Rock Quarry Road. His children helped with the farming and attended Mt. Hope School. (Courtesy of Anne Phillips Holland.)

A 1912 photograph depicts a lime spreader on the Needham L. Broughton farm, located on Vandora Springs Road. (Courtesy of the Needham L. Broughton family, provided by Lucile Bryan Stevens.)

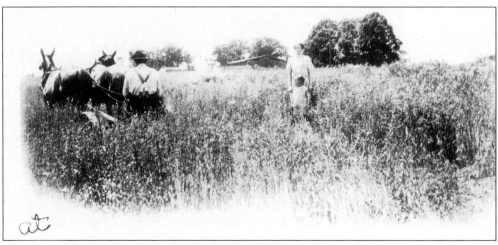

Flossie Broughton and her son, Needham Broughton Jr., stand in a hayfield in 1912. (Courtesy of the Needham L. Broughton family, provided by Lucile Bryan Stevens.)

About 1911, Flossie Bagwell Broughton (age 22) poses with her horse, Rosebud, at her father's farm (Jahazy J. Bagwell) on Jones Sausage Road. (Courtesy of the Needham L. Broughton family, provided by Lucile Bryan Stevens.)

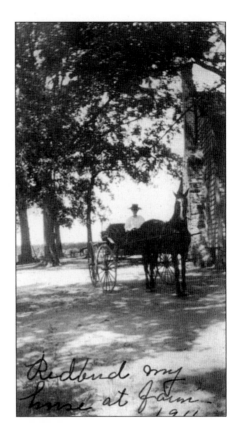

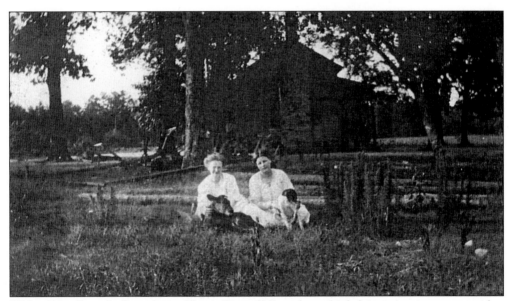

Wife of Needham L. Broughton, Flossie Bagwell Broughton (right) is sitting in a grove with a friend in 1911. Her house on Vandora Springs Road is in the background. (Courtesy of the Needham L. Broughton family, provided by Lucile Bryan Stevens.)

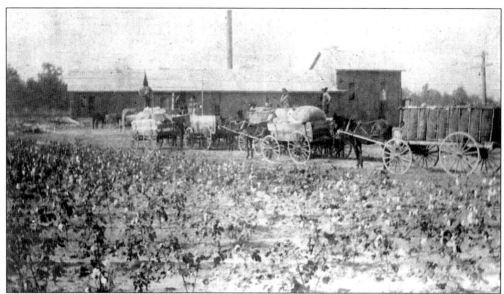

These are two pictures of Needham L. Broughton's cotton gin some time between 1912 and 1914. (Courtesy of the Needham L. Broughton family, provided by Lucile Bryan Stevens.)

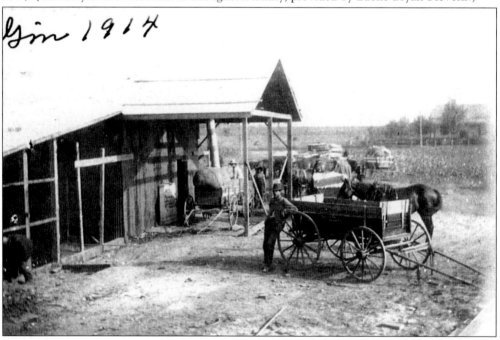

This is a receipt from N.L. Broughton Cotton Seed Company, located near Garner. (Courtesy of the Needham L. Broughton family, provided by Lucile Bryan Stevens.)

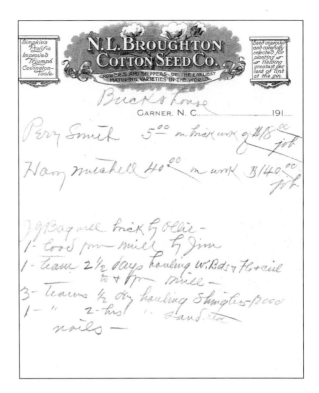

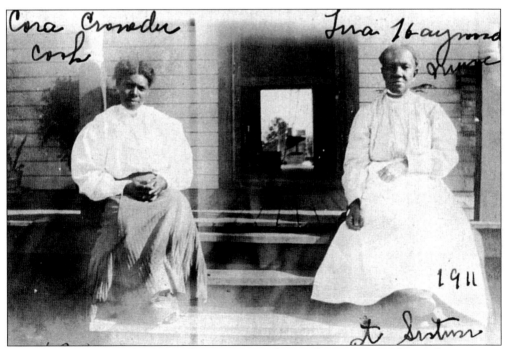

Cora Crowder (left), daughter of Marion Crowder, and nurse Lina Haywood are sitting on a porch in 1911. (Courtesy of the Needham L. Broughton family, provided by Lucile Bryan Stevens.)

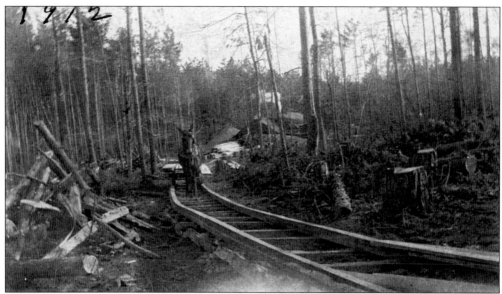

Rail, a vital link in establishing early settlers to towns across America, also contributed to the success of pioneering entrepreneurs. Depicted here is a dummy rail at the Needham Broughton Saw Mill. (Courtesy of the Needham L. Broughton family, provided by Lucile Bryan Stevens.)

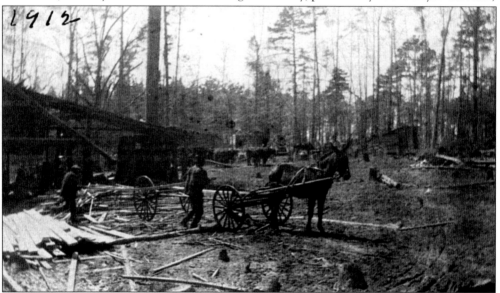

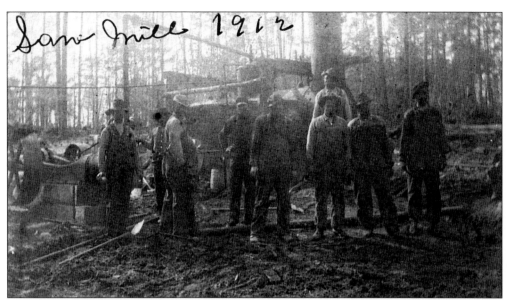

Sawmills and the lumber industry played a crucial role in Garner's early days. Seen here in 1912 is Mallie Carroll with an oxen team. (Courtesy of the Needham L. Broughton family, provided by Lucile Bryan Stevens.)

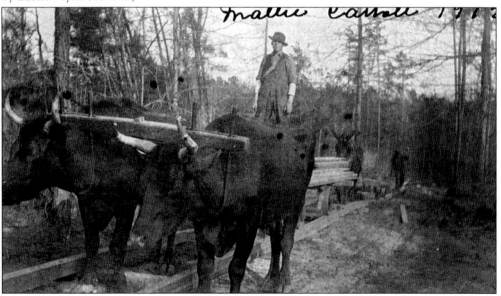

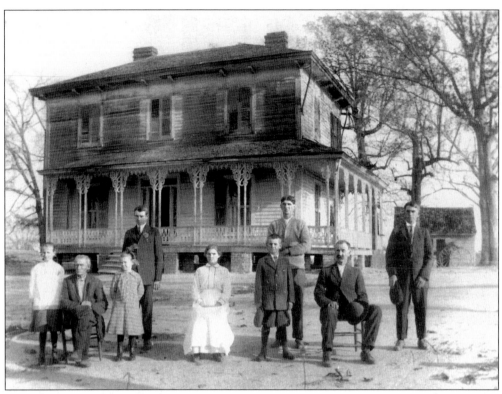

Charlie and Callie Pool Wall's family are pictured here in 1915. They are, from left to right, (front row) two unidentified, Flonnie Wall Holder, Callie Pool Wall, unidentified, and Charlie Wall; (back row) unidentified, Dutch Wall, and unidentified. This house is believed to have been built by William R. Pool around 1870. (Courtesy of Sandra Morris Wall.)

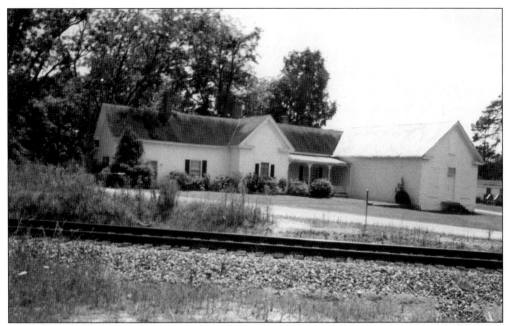

Samuel Watts had this house and store built in the 1870s on Old Garner Road in Auburn. He and his brother, William Watts, came from England to the United States in 1872. A post office was located inside the store until it closed in December 1933; mail was then routed from the Raleigh Post Office.

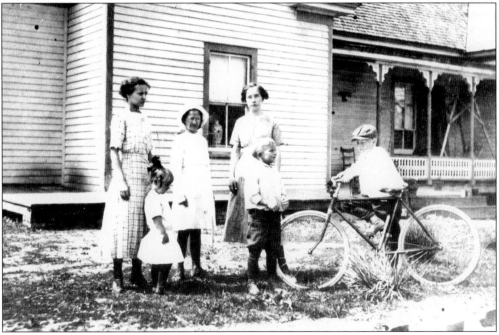

Pictured about 1914 in front of their home, the children of Samuel and Laura Brown Meyer Watts are identified, from left to right, as follows: (front row) Sally Watts, Charles Watts, and William "Billy" Watts (on the bicycle); (back row) Marguerite F. Watts, Mary Emma Watts, and Annie Clyde Watts. Not pictured is Samuel L. Watts. (Courtesy of Jean Watts Wiltsey.)

The James "Jim" Graham and Jessamine Pool Lane cedar house was purchased in 1920 for about $1,500 from the Aladdin Company sales catalog (kit home). They selected the "Pomona" and it was shipped via the railroad in a couple of boxcars. When it arrived at the Auburn Depot, it was delivered to the building site by a horse-drawn wagon (many trips were made by the horse and wagon). Mr. Young, from Clayton, North Carolina, was hired to oversee the construction of the house and commented on the excellent materials and how well each piece was precut and numbered. The Lane family named their new home "Sunshine Villa."

This farm building, seen here in 1920, was located behind the Henry Pool house (known as the Johns house) on Old Garner Road in Auburn. (Courtesy of Rebecca Lane Payne.)

In 1920, this barn would have been found behind the Henry and Katie Pool house (known as the Johns house) on Old Garner Road in Auburn. (Courtesy of Rebecca Lane Payne)

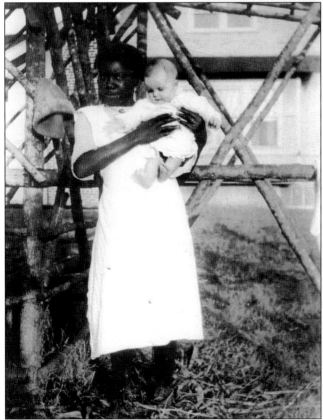

Seen here c. 1922, Bessie Dancey holds Dorothy Lane at a homemade flower trellis that was located in the James G. and Jessamine P. Lane yard. (Courtesy of Rebecca Lane Payne.)

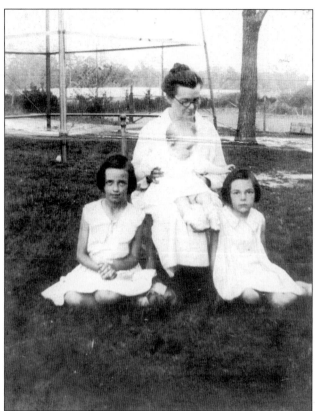

Dorothy Lane, Kate Bryan Pool (holding Betty Lane), and Rebecca Lane are sitting in the Henry and Kate Pool yard (known as the Johns house) at the base of the frame for the water tank *c.* 1932. (Courtesy of Rebecca Lane Payne.)

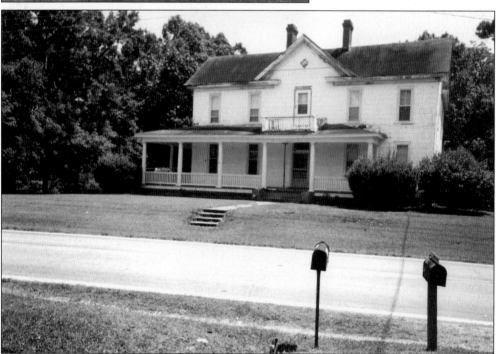

This is a picture of the Johns house on Old Garner Road in Auburn, as it is today.

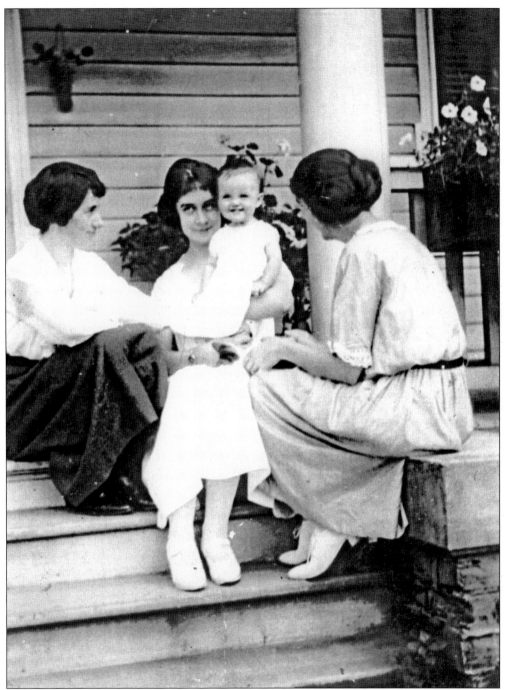

Dr. Bessie Lane (left), Elinor Lane (holding Dorothy Lane), and Margaret Lane (right) pose for this 1923 picture at the Johns' house in Auburn. In 1921, Dr. Bessie Lane graduated from the Woman's Medical College in Philadelphia, Pennsylvania and was one of the first female doctors at Rex Hospital in Raleigh. In 1940, she was the chief of staff of psychiatry. Elinor Lane graduated from Meredith College in Raleigh; Margaret Lane graduated from UNC Greensboro. (Courtesy of Rebecca Lane Payne.)

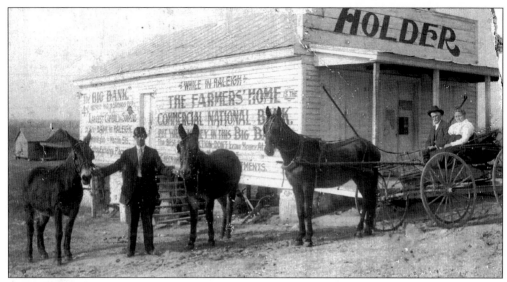

Holder's Store, pictured here in the 1920s, was located on Rock Quarry Road. (Courtesy of Sandra Morris Wall.)

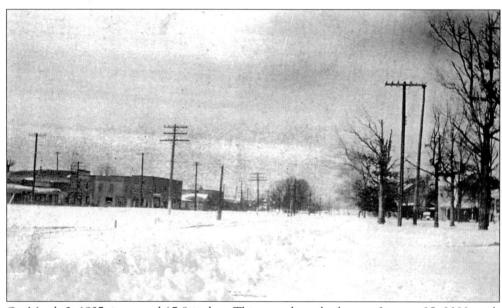

On March 2, 1927, it snowed 17.8 inches. This record was broken on January 25, 2000, with 25.8 inches (recorded at North Carolina's Department of Natural Resources). (Courtesy of the Needham L. Broughton family, provided by Lucile Bryan Stevens.)

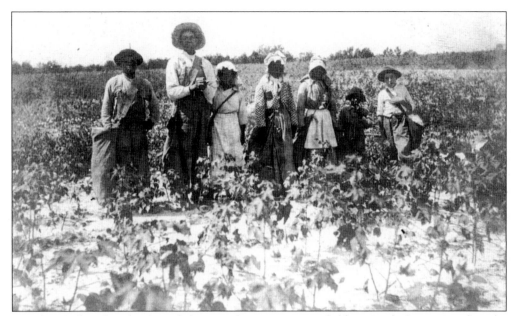

Douglas Phillips (on the far right) is standing in a cotton field on Rock Quarry Road in the Ebenezer community, c. 1930. (Courtesy of Anne Phillips Holland.)

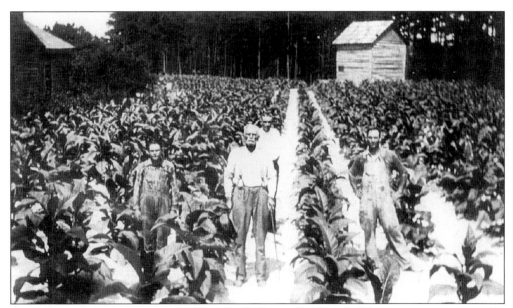

Henry Bagwell (with the cane) lived on Rock Quarry Road in the Ebenezer community and is standing in his tobacco field in the early 1930s. A tobacco barn is visible in the background. (Courtesy of Ann Phillips Holland.)

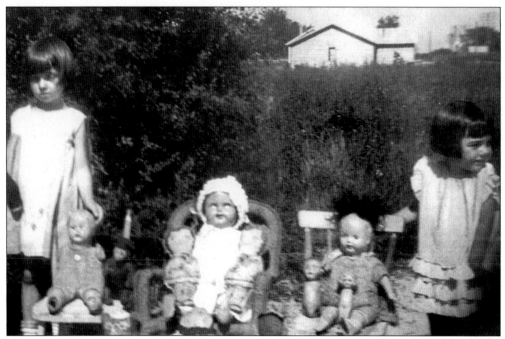

In 1935, Dorothy Lane (left) and Rebecca Lane (right) could be found playing with their dolls and having tea parties in their backyard on Old Garner Road in Auburn. Charles Watts's automobile garage is in the background. (Courtesy of Rebecca Lane Payne.)

James G. Lane hired Walter McCoy to build a log cabin playhouse with a fireplace for his daughters Dorothy and Rebecca, in their backyard. Sometimes the girls roasted hot dogs or marshmallows in the fireplace. In 1935, Rebecca Lane (left) and Adair Whisenhunt (right) are seen standing in front of the log cabin playhouse. (Courtesy of Rebecca Lane Payne.)

When Harvey A. Holder moved his dairy farm from Rock Quarry Road in 1927, the cows followed the lead cow to the new farm. His wife, May Bagwell, operated a grocery store on their farm from about 1949 to 1963 or 1964. The house and farm were located on Highway 50 South (also known as Benson Road) near Garner, not far from Swift Creek. (Courtesy of Clarence Holder.)

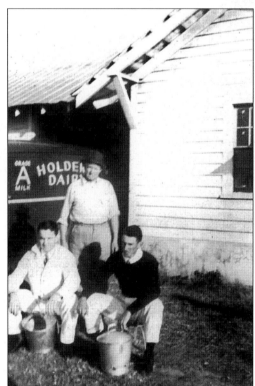

In front of Holder's dairy truck at the barn in 1941 are, from left to right, the following: Poe Holder (Harvey A. Holder's son), Harvey A. Holder, and Rand Bryan (Harvey A. Holder's son-in-law). (Courtesy of Clarence Holder.)

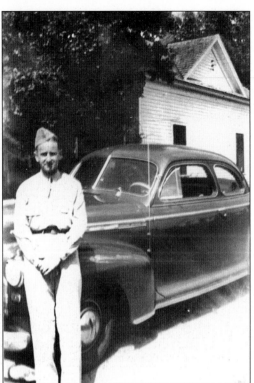

Kenneth Holder poses in his 1943 U.S. Army uniform in his parents' yard on Highway 50 South near Garner. His father was Harvey A. Holder.

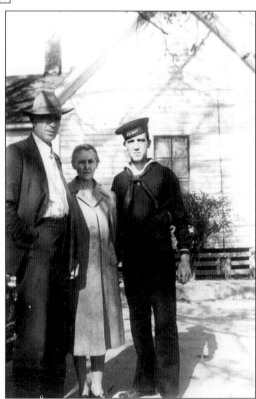

Leon Bagwell is pictured in 1943 with his parents, Dallie and Pearl Bagwell of the Ebenezer community, in his Navy uniform. (Courtesy of Ann Phillips Holland.)

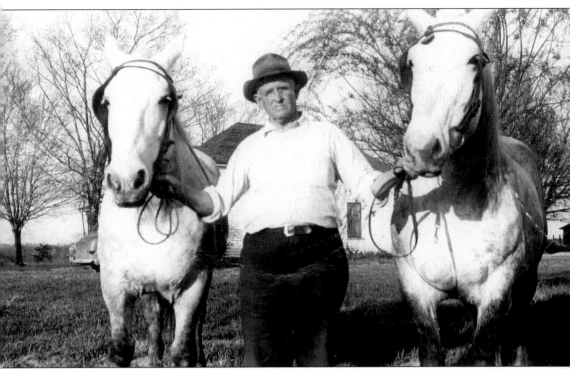

Pictured in 1944, Harvey A. Holder stands between his two favorite horses, Trixie and Belle. (Courtesy of Clarence Holder.)

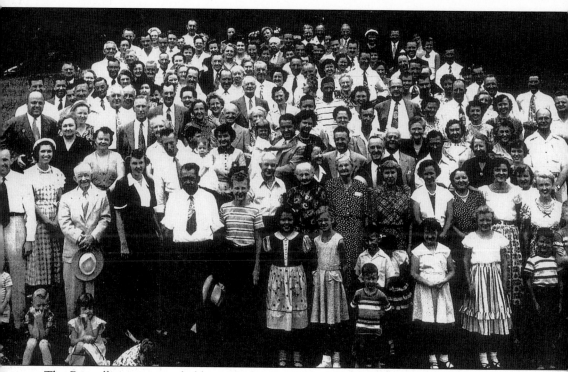

The Bagwell reunion was held every year at someone's home from the early 1900s to the late 1990s. Pictured is the Bagwell reunion in 1950. (Courtesy of Sandra Morris Wall.)

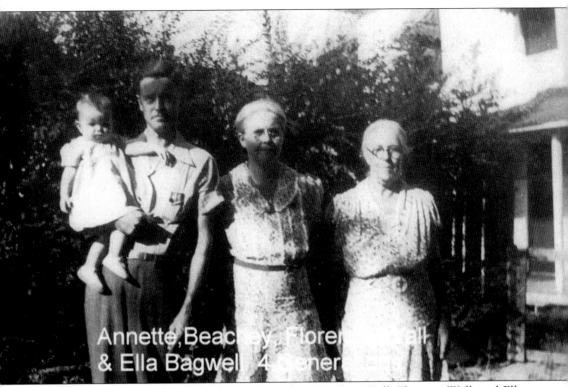

Annette, Beachey, Floren... Wall
& Ella Bagwell, 4 gener...

From left to right, Annette Wall, held by her father, Beachey Wall, Florence Wall, and Ella Bagwell gathered for a family picture (four generations) c. 1950, in the Ebenezer community. (Courtesy of Sandra Morris Wall.)

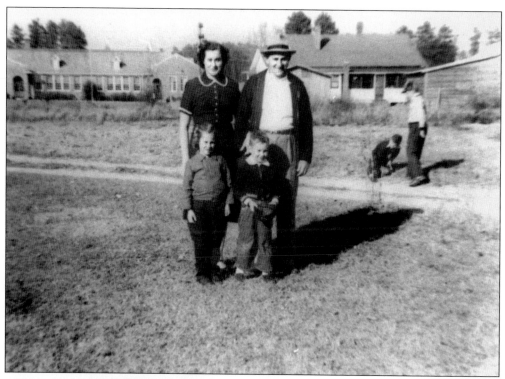

Standing in the front yard of the Wilfred E. Buffaloe house in Auburn about 1950 are, from left to right, the following: (front row) Mary Kaye Buffaloe and Wilfred E. Buffaloe Jr.; (back row) Mary Helen Strickland Buffaloe and Wilfred E. Buffaloe (the two boys' identities are unknown). Mt. Auburn School and the back of the Raymond Powell house appear in the background. Mt. Auburn School was built about 1927 to serve the children of Mt. Moriah and Auburn communities.

Tommy Wall (left) and Bill Goodwin (right) pose on Tommy's pony car in 1950–1951. They were riding around Bill's grandfather's (Ernest Wall) farm off Rock Quarry Road in the Ebenezer community. (Courtesy of Sandra Morris Wall.)

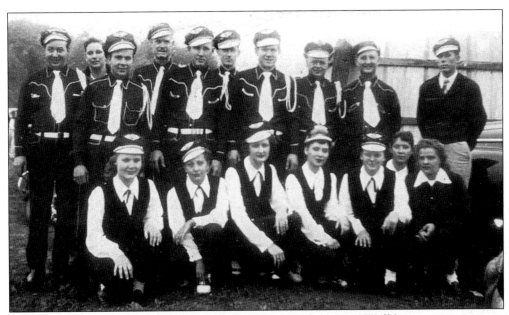

This is a motorcycle club in the 1950s. (Courtesy of Sandra Morris Wall.)

A group of students are pictured in front of Mt. Auburn School in Auburn about 1954–1955. They are, from left to right, (first row) all unidentified; (second row) unidentified, Ann Phillips, Martha Burnette, and two unidentified; (third row) unidentified, Mary Kaye Buffaloe, and Peggy Moon. (Courtesy of Ann Phillips Holland.)

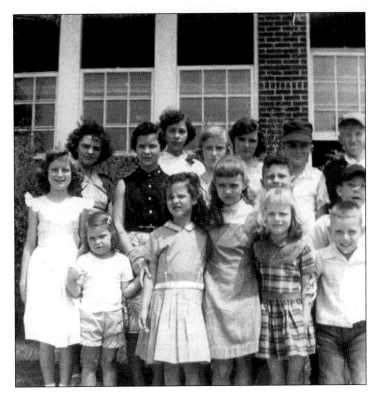

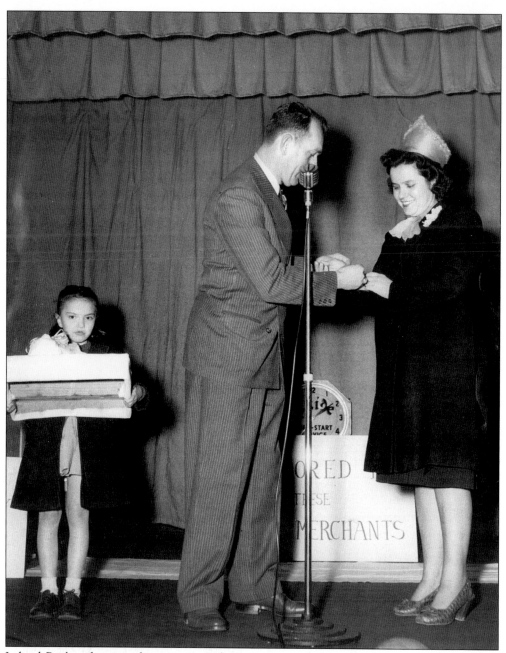

Leland Poole, who owned a store in Auburn, is seen with Margaret Bagwell Phillips on the stage at Mt. Auburn School in the Auburn community in the 1950s. (Courtesy of Anne Phillips Holland.)

# Two

# GARNER'S STATION AND GARNER THE TOWN

## 1880s TO 1930

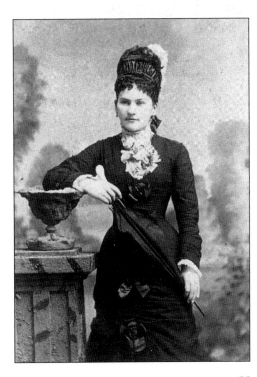

The portrait of 18-year-old Nelia Britt (1863–1899) was made in Raleigh's Wharton's Studio. Nelie married Jahazy J. Bagwell. (Courtesy of the Needham L. Broughton family photographs, provided by Lucile Bryan Stevens.)

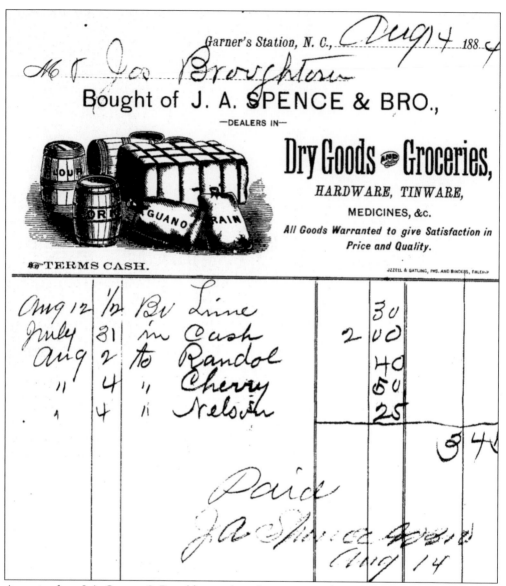

_Garner's Station, N. C.,_ Aug 14 188_4_

M̅ Jos Broughton

## Bought of J. A. SPENCE & BRO.,

—DEALERS IN—

### Dry Goods _and_ Groceries,

#### HARDWARE, TINWARE,

MEDICINES, &c.

_All Goods Warranted to give Satisfaction in Price and Quality._

TERMS CASH.

JZZELL & GATLING, PRS. AND BINDERS, RALEIGH

|  | |  | | |
|---|---|---|---|---|
| Aug 12 | ½ | By Lime | | 30 |
| July | 31 | in Cash | 2 | 00 |
| Aug | 2 | to Randol | | 40 |
| " | 4 | " Cherry | | 50 |
| " | 4 | " Nelson | | 25 |
| | | | | 3 45 |

Paid
J. A. Spence & Bro
Aug 14

A receipt from J.A. Spence & Bro. (dry goods and grocery store) was given to Joseph Broughton on August 14, 1884 for items that had been purchased at his store in July and August. Garner, at that time, was known as Garner's Station. (Courtesy of Lucile Bryan Stevens.)

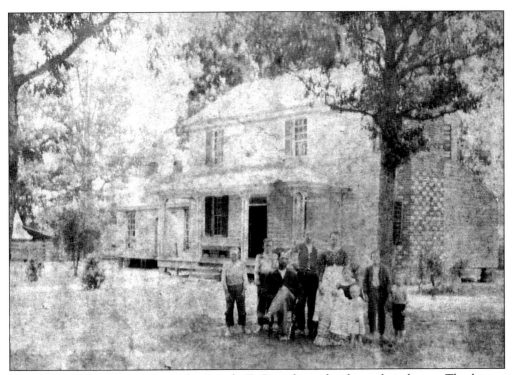

This is an 1887 photograph of the Joseph T. Broughton family at their home. The house, constructed around 1823 (known as the "Avera-Broughton-Bryan house"), is the oldest house in Garner. Family members, listed from left to right, are (front row) Joseph T. Broughton, Martha Snelling Broughton (husband and wife seated), baby Helen in Martha's lap, and Needham; (back row) Marvin, Thomas, William, Fannie, John, and Numa. Joseph Broughton was an agriculturist, mayor of Garner from 1907 to 1909, active member of the Garner Methodist Church, and a Democrat. (Courtesy of Lucile Bryan Stevens.)

| PUBLIC SCHOOL FUND. | Office of Treasurer of Wake County, |
|---|---|

Raleigh, N. C., *May 21* 18*91*

RECEIVED from *Joseph T Broughton*

*Fifty* X. DOLLARS, 100

on account of *School fund*

*School house and lands of #1 St marys District*

*L O Longel*
Treasurer Wake County.

This receipt shows that Joseph T. Broughton gave $50 to the school fund for the purchase of land and building construction of #1 St. Mary's District School on May 2, 1891. (Courtesy of Lucile Bryan Stevens.)

This house, built c. 1850, was moved in the early 1900s about 300 yards east on Old Garner Road so that the Lon Yeargin house could be built. The outside walls contain imbedded miniballs (commonly used in Civil War–era, quick-loading muskets). It is told that this house was used as a hospital during the Civil War. Dr. Merritt Z. Gattis resided here with his wife, Martha Dupree Gattis, in the late 1800s.

This framed house was built in the 1850s by Burton Dupree on land that he inherited from his parents, James and Keziah Dupree, in 1852. It is located on St. Mary's Street in Garner.

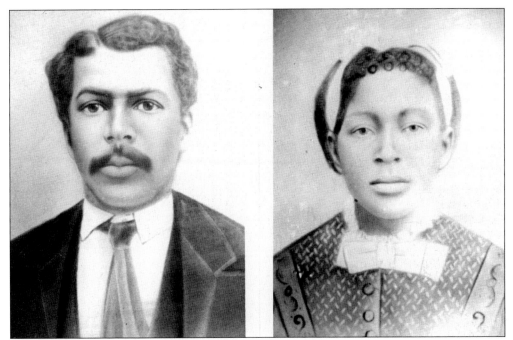

Allen Haywood is seen here with his wife, Betsy Roundtree Haywood. Allen Haywood was a schoolteacher for the African-American community in Garner and a member of Popular Springs Baptist Church. (Courtesy of Chilly and Elizabeth Haywood.)

Allen Haywood purchased land from Eli Dupree in 1877 to build his family home. Although remodeled, the house is located on Main Street in Garner (formerly Railroad Street) and remains a poignant declaration of Allen and Betsy Haywood's character and prosperity.

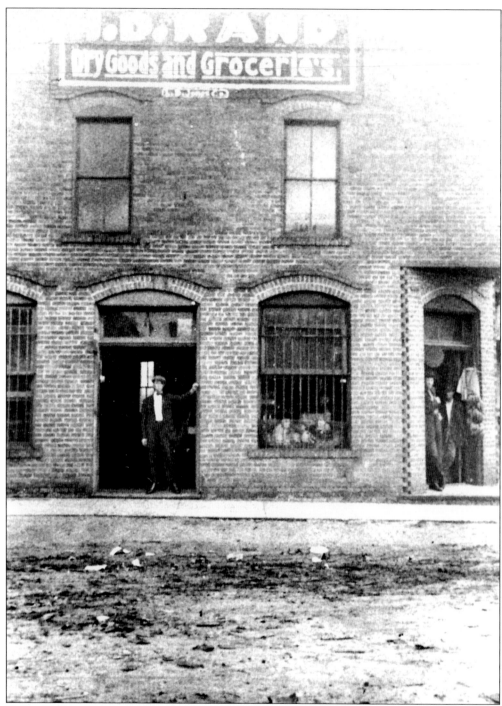

Hallie D. Rand's Dry Goods and Grocerie was erected about 1895 on Railroad Street (now Main Street) in Garner. Rand strategically relocated his mercantile business from Rand's Mill to be more easily accessible to the railroad. He was mayor of Garner sometime between 1917 and 1932 (the records burned). Delos Creech is standing in the front door of the store (the men at the corner entrance are unknown). (Courtesy of Bobby Creech.)

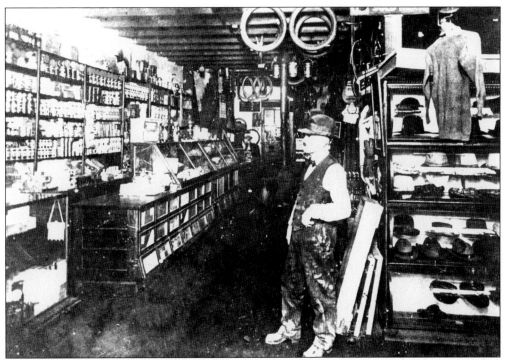

Hallie D. Rand is standing inside his store about 1900. (Courtesy of Margaret, Betty, and Mary Marshall, daughters of William R. and Elizabeth Rand.)

This receipt shows that Jim Creech paid H.D. Rand $57.40 on September 20, 1900. (Courtesy of Bobby Creech.)

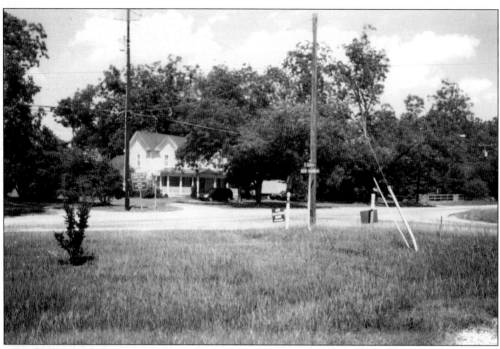

Jahazy "Hazy" J. Bagwell operated a farm on Jones Sausage Road. In 1895, he built this two-story frame house on Old Garner Road in Garner and was a representative to the North Carolina Legislature. Later, he opened J.J. Bagwell (a dealer of furniture, buggies, wagons, and undertakers supplies). (Courtesy of Bobby Creech.)

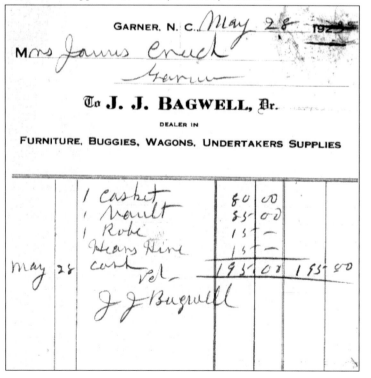

This receipt dated May 28, 1923, to Mrs. James Creech from J.J. Bagwell was for her purchase of the essential items during her time of grief. Note that tax was not accessed on items purchased for her passing loved one. (Sales slip from the 1920s; Courtesy of Bobby Creech.)

Jahazy Bagwell is pictured with his
second wife, Jenny Johns Bagwell.
(Courtesy of the Needham L.
Broughton family, provided by Lucile
Bryan Stevens.)

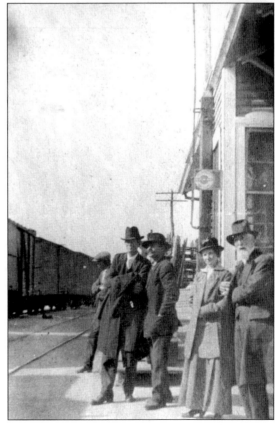

This is an early-1900s snapshot of rail
passengers waiting outside Garner
Depot in Garner. (Courtesy of William
"Bill" Middleton.)

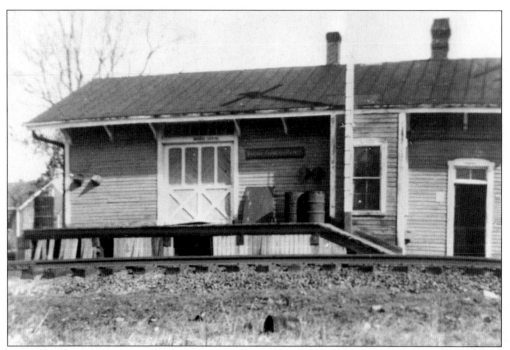

This is Garner Depot as it appeared in 1954 prior to Hurricane Hazel. Hurricane Hazel destroyed the east end of the building. (The depot was built about 1902.) It is currently being restored and will serve as a museum.

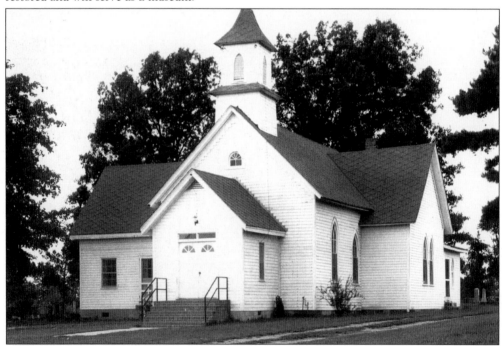

Hayes Chapel Christian Church, the oldest church in Garner, was organized in 1859. Henry B. Hayes was minister and Henry Utley was the church clerk. Pictured is the church, located on Old Garner Road, as it looked in the 1950s. (Courtesy of Bobby Creech.)

This is a picture of Hayes Chapel Christian Church Cemetery, as it appeared in the early 1900s. (Courtesy of Bobby Creech.)

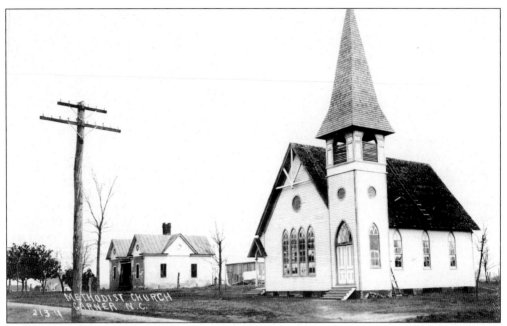

Garner Methodist Church was dedicated in 1892 on Main Street in Garner. The church's origin dates back to around 1870. It was known formerly as Beulah Grove Methodist, a bush arbor near Garner. In the mid-1950s, Garner Methodist Church purchased land off Highway 70 to build a church to better serve the growing congregation of 500 members. The Kuester house (built about 1912) is to the left of the church.

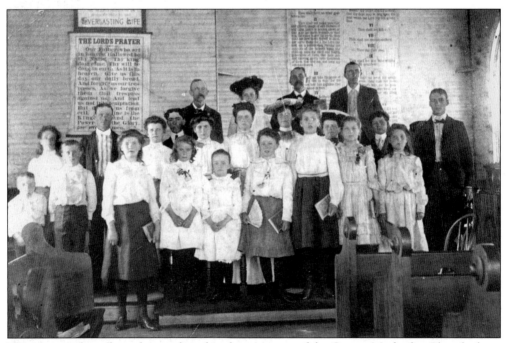

This is a snapshot of members gathered in the sanctuary of the Garner Methodist Church about 1915. (Courtesy of Betty Smith Buffaloe.)

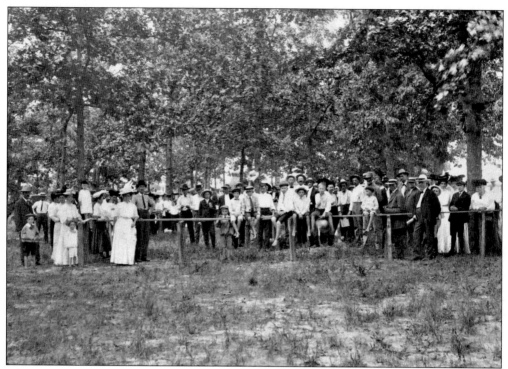

This picnic was held in Garner in 1902. (Courtesy of Lucile Bryan Stevens.)

John F. Broughton was a farmer and Alice Elizabeth Penny Broughton was a teacher at Mt. Hope School on Rock Quarry Road. (Courtesy of Elise Mae Broughton Stephens.)

These four houses were located on East Garner Road across from downtown Garner. They are, from left to right, as follows: part of the Banks house, John F. Broughton house (built about 1900), Needham L. Broughton house, and an unidentified house.

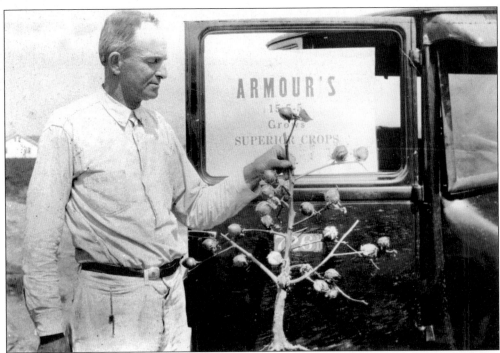

Holding a cotton plant, John F. Broughton is standing at an automobile about 1930. He was a farmer and owned John F. Broughton Field Seed and Feed Company. (Courtesy of Elsie Mae Stephens.)

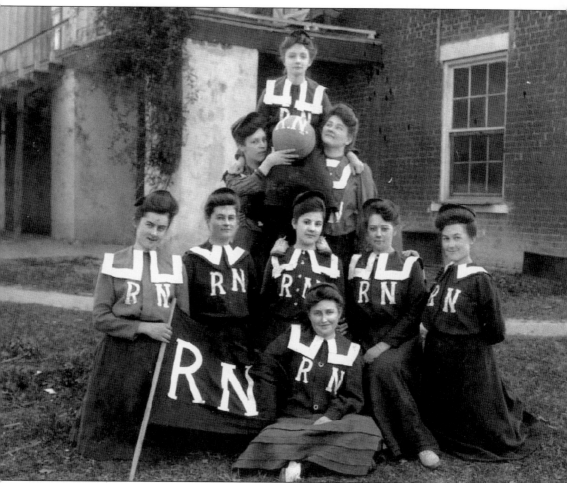

Helen Broughton, daughter of Joseph T. Broughton, of Garner attended Louisburg College in Louisburg and was on the 1905 girls' basketball team, known as the "Ready Nine." She is on the left holding the R.N. ("Ready Nine") flag. (Courtesy of Lucile Bryan Stevens.)

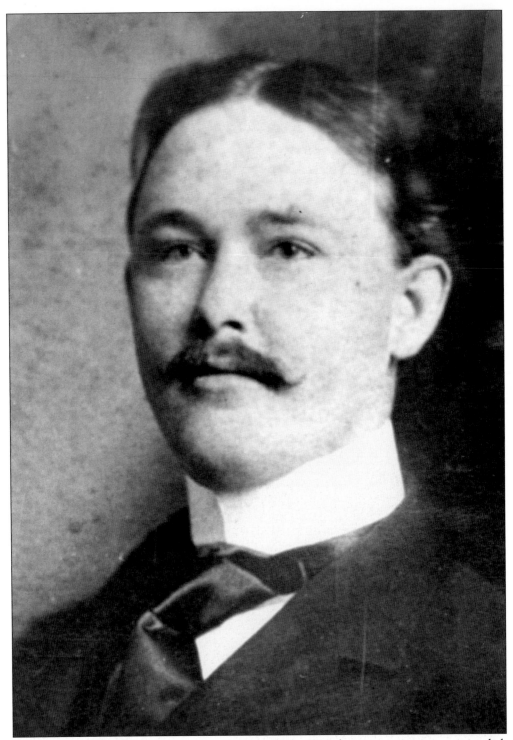

In 1883, Garner Station was incorporated; however, in 1891 the incorporation was rescinded. It was 14 years before Garner received reinstatement as a town. In 1905, J.B. Richardson was the first mayor of the Town of Garner.

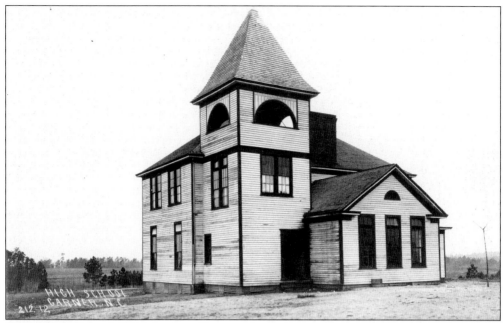

Garner High School ("Old Academy") is seen here after reconstruction. The original structure was destroyed by lightning in 1906 and the school was closed in 1926. This building was once located at the Garner Lions Ball Field on Main Street.

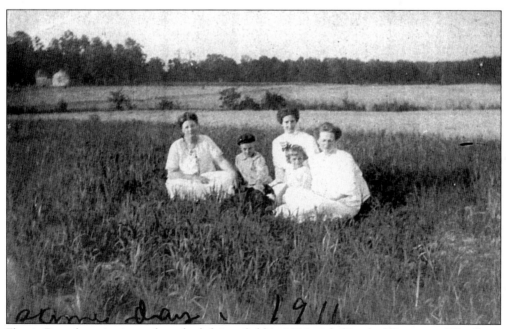

Flossie Broughton is pictured on the left in a field in 1911 with friends. (Courtesy of Needham L. Broughton family photographs, provided by Lucile Bryan Stevens.)

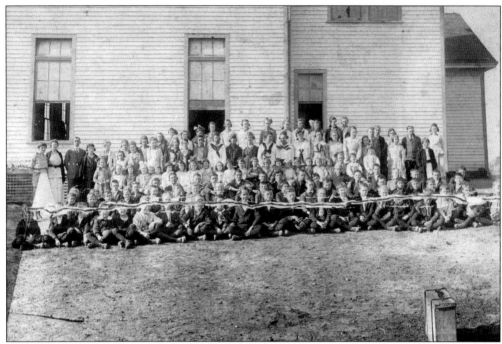

Students and teachers were photographed at the "Old Academy" about 1915 to 1920. The photographer included someone's suitcase as well.

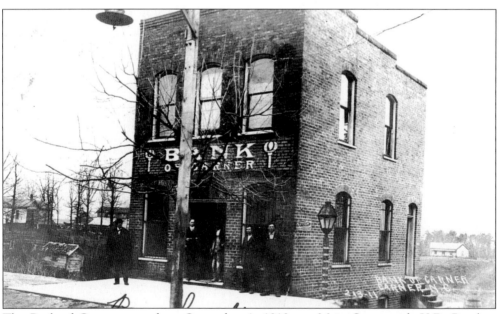

The Bank of Garner opened on September 1, 1910, on Main Street with H.D. Rand as president and J.A. Weathers as cashier. Troy Jones's house and barns are visible to the left of the bank and Rosa Phillips' house is to the right. In 1918, the bank name changed to Garner Banking and Trust Company. In the 1960s, the vault was removed and sold to the N.C. State University Club in Raleigh. (The men in front of the bank are unknown.) (Courtesy of Lucille Bryan Stevens.)

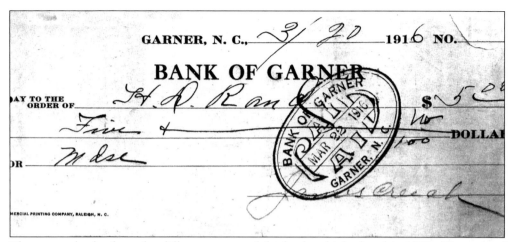

These two checks show the different names of the bank, which closed in 1931. (Courtesy of Bobby Creech.)

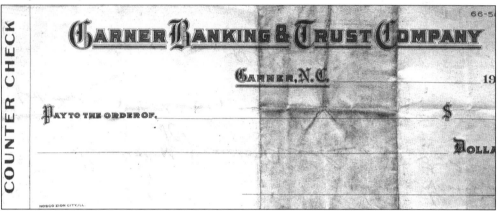

Flossie Broughton plays with Francis Bryan, Elizabeth Bryan, and Woody Broughton outside the Sam and Helen Bryan home in 1912. Notice the unhitched carriages in the background and the covered well in the left corner of the frame. (Courtesy of Needham L. Broughton family photographs, provided by Lucile Bryan Stevens.)

Dr. J. Samuel "Sam" Buffaloe was born in St. Mary's township in 1872; he completed State College (N.C. State University) in 1897 and graduated from Baltimore Medical College. Dr. Buffaloe originally practiced in partnership with Dr. Braxton Banks until 1902 and then opened his own practice. He used a horse and buggy to make house calls in the early years, and later James Rand and Hubert Bryan drove him in his automobile. Dr. Buffaloe was a patriarch in the community and practiced medicine until the 1960s. He was facetiously known for administering his patients and himself a "pink pill." (Courtesy of Nannie Kelly Macon.)

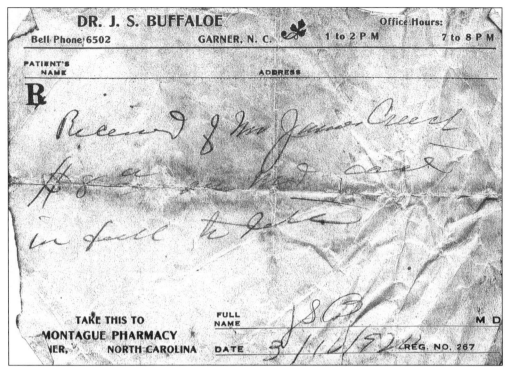

On his prescription form, Dr. J. Samuel Buffaloe has written "Rec'd of Mr. James Creech $8 med care in full to date, Mar. 16, 1920." (Courtesy of Bobby Creech.)

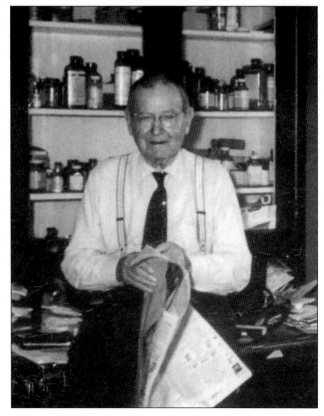

Dr. J. Samuel Buffaloe is seen here in his office, located above the drugstore on Main Street, in the 1950s. (Courtesy of Lucile Bryan Stevens.)

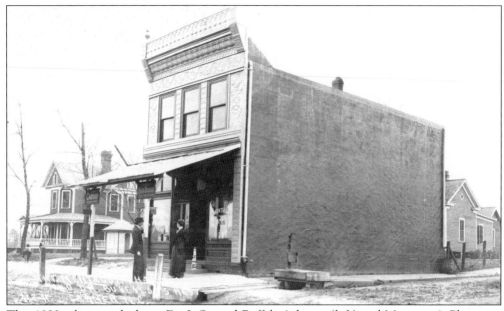

This 1920s photograph shows Dr. J. Samuel Buffaloe's home (left) and Montague's Pharmacy on Main Street in Garner. George B. Montague, born in 1854 in Granville County, was educated at Bethel Academy in Person County. After his death in 1923, the pharmacy closed. Dr. Buffaloe's house was torn down in the early 1970s and the Garner Lions Club built their structure. Montague's Pharmacy was torn down in the 1940s.

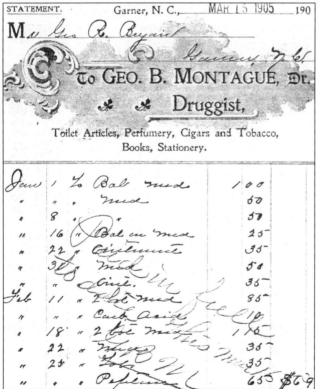

This is a list of items purchased by S.T. Carroll from Geo. B. Montague's Pharmacy; the bill started in December 1899. (Courtesy of Bobby Creech.)

Sam and Helen Bryan's children are pictured in 1914. On the back row is Francis and in the front are Lucile (in the chair) and Elizabeth.

Minnie Buffaloe, wife of Dr. J. Samuel Buffaloe, poses with her music pupils on the front steps of her house in May 1915. They are, from left to right, as follows: (first row) Emma Mae Bryan, Lucile Bryan, and Elizabeth Bryan; (second row) Tignal Mitchiner (in hat); (third row) Virginia Mitchiner, Charlotte Brooks, and Craven Broughton; (fourth row) Lydia Mitchiner and Frances Bryan. Minnie Buffaloe is standing on the porch near Frances Bryan; Helen Bryan (mother of Frances, Lucile, and Elizabeth Bryan) is holding onto the porch post. John Montague is hiding behind the porch post, and his half-sister, Lillian Montague, is leaning to the far right. (Courtesy of Lucille Bryan Stevens.)

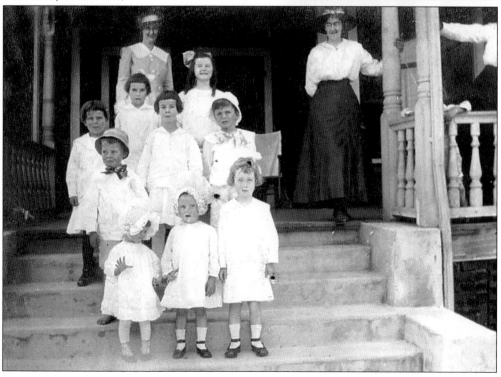

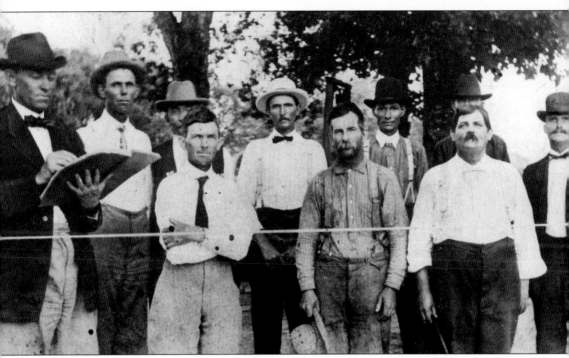

These are members of the Garner Junior Order, *c.* 1915. They are, from left to right, as follows: (front row) Billy Bryan (holding book), John Mitchiner, Jim Creech (holding hat), and Jim Carroll; (back row) David Stancil, J.D. Johnson (mayor of Garner from 1909 to 1913), Bud Smith, Lon Yeargan, Oscar Jones, and Percy Mitchiner. (Courtesy of Bill Creech.)

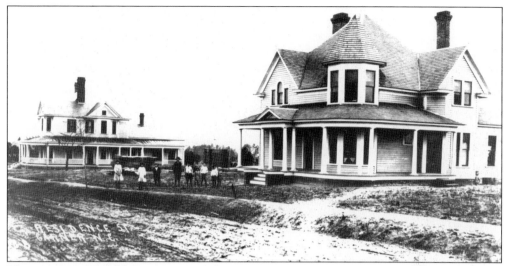

This picture postcard from about 1915 shows the Henry Bryan house (built *c.* 1910) on the left and the W.L. Brooks house (built *c.* 1912) on the right. Both houses are located on New Rand Road. Bryan operated Henry Bryan & Co. on Main Street in Garner; Brooks worked with the railroad. (Courtesy of N.C. Department of Archives.)

This is a receipt from Henry Bryan & Co. to Jim Creech on November 1, 1921. (Courtesy of Bobby Creech.)

Fannie Lee Broughton, daughter of Flossie and Needham L. Broughton, is sitting in her stroller in 1915. (Courtesy of the Needham L. Broughton family, provided by Lucile Bryan Stevens.)

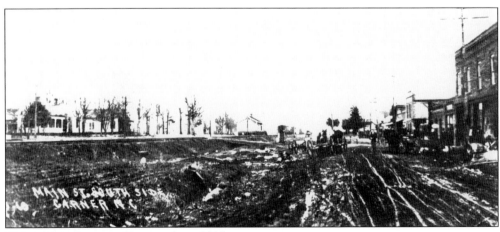

This is Main Street in Garner, about 1915.

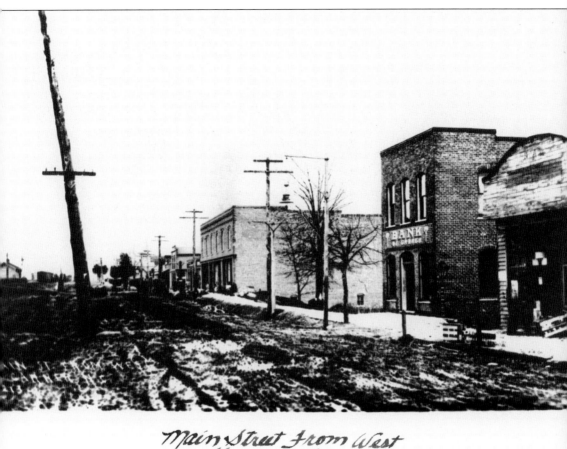

*Main Street From West*
*Garner, N.C.*
*Ca 1918*

This is another view of Main Street in Garner about 1915.

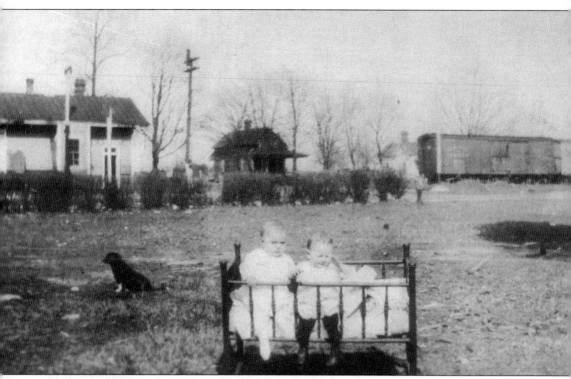

Johnny and Ethel Johnson (children of Herman and Lina Johnson) are sitting in a cradle c. 1915, with the Garner Depot and several railroad boxcars in the background. (Courtesy of Bobby Creech.)

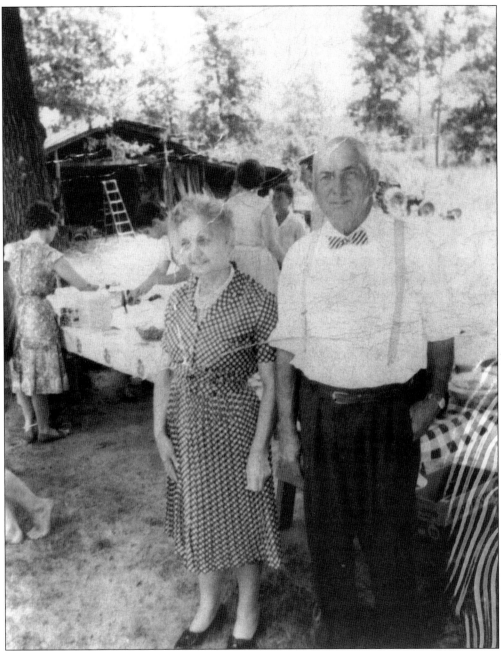

Herman and Lina Massey Johnson are standing in front of a picnic table at their home on New Rand Road (part of his farm is the Pinehurst Park housing development). He was a blacksmith, logger, and farmer; he also shoed horses. He and his helper, James Rand, died from injuries received from a motor vehicle accident in 1968. (Courtesy of Bobby Creech.)

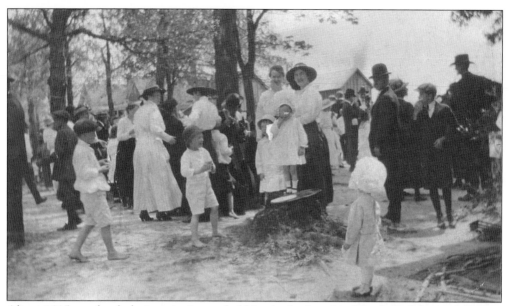

About 1915, a school-closing picnic was held in the backyards of Dr. J. Buffaloe and George Montague on Main Street in Garner. They are identified, from left to right, as follows: (at the stump) Lillian Montague with her half-brother, John (in front of her); (standing on the stump) Helen Bryan and her daughter, Lucile Bryan Stevens; (right of the stump) Dr. J.S. Buffaloe (in a derby hat) and his son, Herman Buffaloe (in cap), Joseph T. Broughton (the tall man with a hat) to the far right; (foreground) Emma Mae Bryan (wearing a white cap), age about 3 or 4 years old; and (left of the stump) Woodrow Broughton (in white suit with short pants and barefooted). Woodrow Broughton's mother, Flossie Broughton, is second from the tree in the white dress with a hat facing Cora Bryan in the white blouse and dark skirt with a hat. The other people in this image could not be identified. (Courtesy of Lucile Bryan Stevens.)

This train is arriving in Garner after the snow storm in 1917. The coal car almost eluded the photographer. (Courtesy of the Needham L. Broughton family photographs, provided by Lucile Bryan Stevens.)

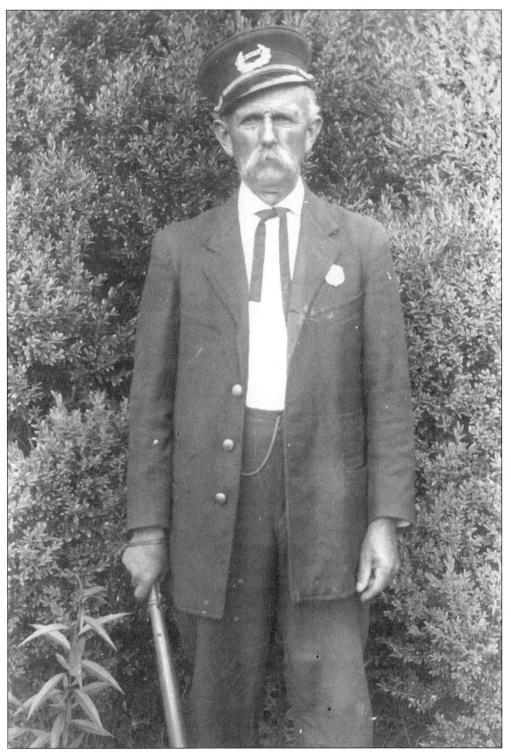

Troy Jones poses in his Garner police uniform in 1916. He lived on Rand Mill Street and was a carpenter by profession. (Courtesy of Martha Bryan Liles.)

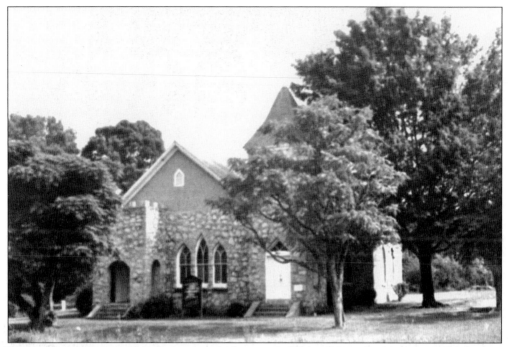

Wake Baptist Grove Church, previously known as Wake Piney Grove, was established in Garner as a bush arbor in 1868. (Bush arbors, primitively constructed from "the bush," were a predecessor of church structures recognized today.) The African-American stone church, as viewed here, was built about 1917 on the site where the original building was destroyed by a storm. The church is located on Old Garner Road. Wake Baptist Grove Church sold this property and built a new church on Main Street (former location of Garner Methodist Church).

In 1918, Martha Stevens Bryan (born in 1841) is holding her granddaughter, Kathleen, in the yard at her son's house (J. Samuel Bryan) in Garner. (Courtesy of the Needham L. Broughton family photographs, provided by Lucile Bryan Stevens.)

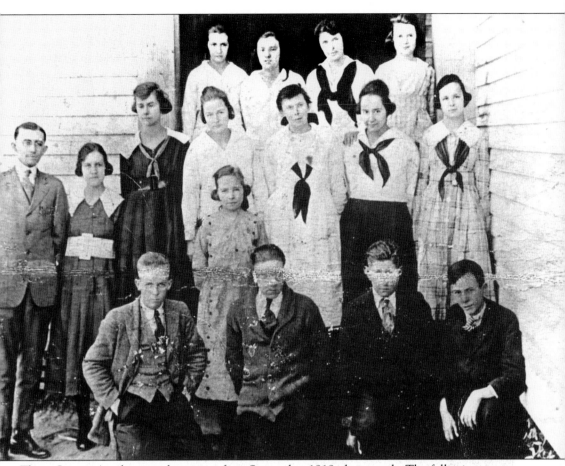

These Garner Academy students pose for a September 1919 photograph. The following names were listed but not identified in any order: Julian Rose (teacher), Fannie Carter, Braxton Banks, Irma Broughton, Elizabeth Mitchiner, Ruby Apple, Estelle Simpkins Nannie Carter, Gladys Broughton, Mary Mitchiner, Eleneda Hall, Lewis Mitchiner, Herman Buffaloe, Jack Mitchell, and Robert Brooks.

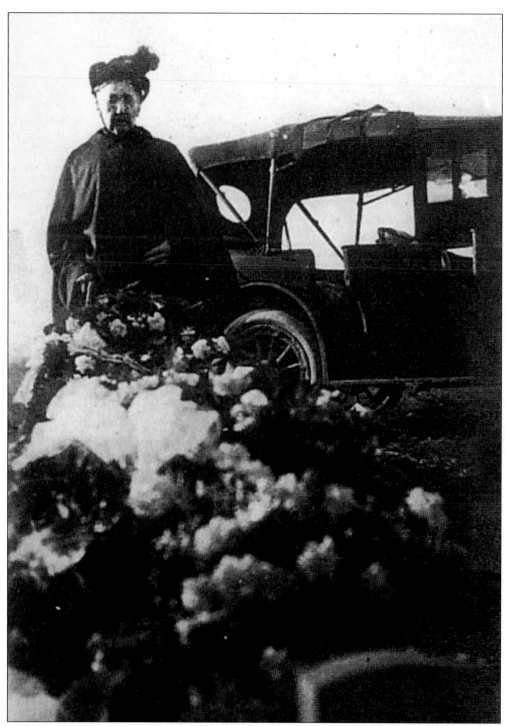

Catherine Broughton Hicks (b. 1839) is shown at her brother Joseph T. Broughton's funeral in 1919 at the Town of Garner Cemetery. Catherine, known as Kate, married Henry Hicks in 1865. Henry was a Raleigh druggist who invented Capudine, a remedy for headaches and gripp (1900s term for the flu). (Courtesy of Lucile Bryan Stevens.)

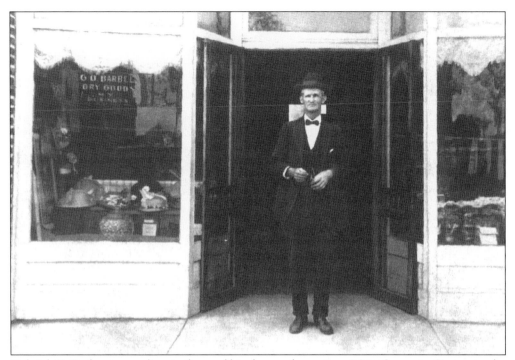

Gabriel O. Barber is standing in front of his dry goods store on Main Street in Garner in the 1920s. (Courtesy of Phyllis Barbee Anders.)

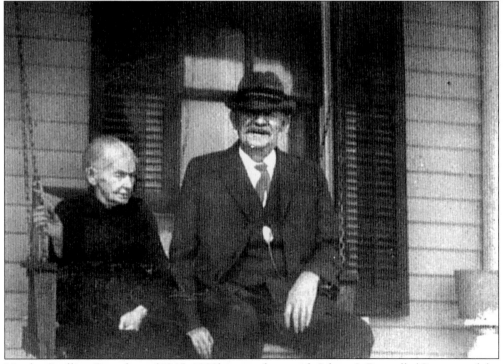

Martha Snelling Broughton (1845–1930) is seen here with Jahazy J. Bagwell. (Courtesy of the Needham L. Broughton family photographs, provided by Lucile Bryan Stephens.)

These people are standing in front of the Garner Depot in 1923, with the Garner Methodist Church visible to the left. They are, from left to right, as follows: Fletcher Harper, Woody Broughton, Louise Broughton, Fannie Lee Broughton, Craven Broughton, Jack Broughton, and Worth Whitaker (in front of Jack Broughton). (Courtesy of the Needham L. Broughton family, provided by Lucile Bryan Stevens.)

This is a receipt from Buffaloe Brothers Co., Inc. to Mrs. James Creech on March 10, 1925. Bryant Ralph and Burwell B. Buffaloe operated the grocery and hardware store on Main Street in Garner. (Courtesy of Bobby Creech.)

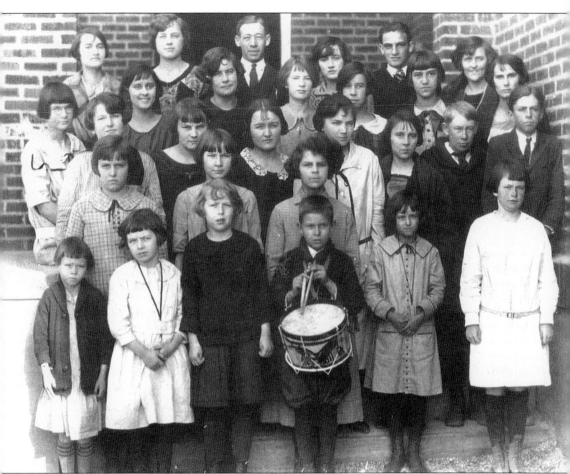

A music class from Garner High School posed for this picture about 1924. They are, from left to right, as follows: (front row) Mary Lee Penny, Blanche Buffaloe, Louise Broughton, unidentified (drummer), Emma Mae Bryan, and Fannie Lee Broughton; (second row) three unidentified; (third row) Pearl ?, Sally Watts, Moriah Broughton, Mildred Collins, Woodrow Broughton, and Craven Broughton; (fourth row) unidentified (seated), Eloise Collins, Alene Buffaloe, Carrie Allen, Charlotte Brooks, Ethel Wrenn, and Lydia Mitchiner; (fifth row) Linda Rand, Virginia Griffis, Marshall Rand, and unidentified.

Tom Banks, Garner's well-known and respected lawyer, is seen here in the 1920s. He graduated from Duke University and was the interim principal of Garner High School for one year and then went to Harvard for his law degree. His home, located on the corner of Creech and Old Garner Roads, remains a pillar of his success. Decendents of Tom Banks still reside in the house. (Courtesy of Needham L. Broughton family photographs, provided by Lucile Bryan Stevens.)

Needham L. Broughton Jr. plays with collie puppies on the porch of his home in 1926. (Courtesy of Needham L. Broughton family photographs, provided by Lucile Bryan Stevens.)

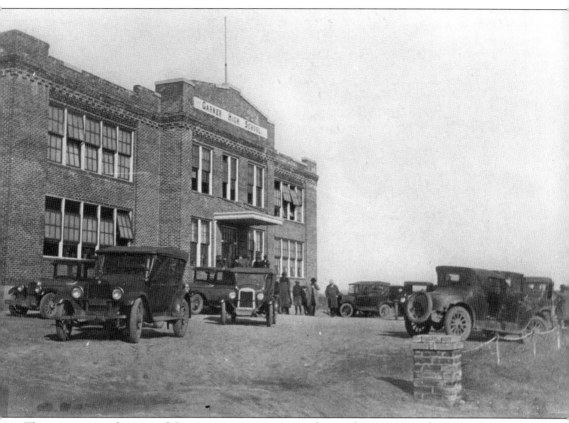

This picture is indicative of Garner citizens exercising their right to vote in the 1926 election. Polling stations, like today, were held at schools; this one was held at Garner High School on Old Garner Road. Garner High School was built in 1923. (Courtesy of the Needham L. Broughton family, provided by Lucile Bryan Stevens.)

In 1927, Needham L. Broughton Jr. and Cecelia Phillips are holding Polly the cat. (Courtesy of the Needham L. Broughton family, provided by Lucile Bryan Stevens.)

Elizabeth "Lib" P. and William R. Rand are pictured at Dr. J. Samuel Buffaloe's house in Garner about 1927. She came to Garner in 1926 to teach school and roomed at Dr. Buffaloe's house. Mrs. Rand was very active in organizing the Garner Woman's Club in 1928, involved in her community and Garner Methodist Church, as well as known for her daffodils and many other flowers that she grew in her gardens at her home on Perdue Street. She helped preserve Garner history. (Courtesy of Betty, Margaret, and Mary Marshall, daughters of William and Elizabeth Rand.)

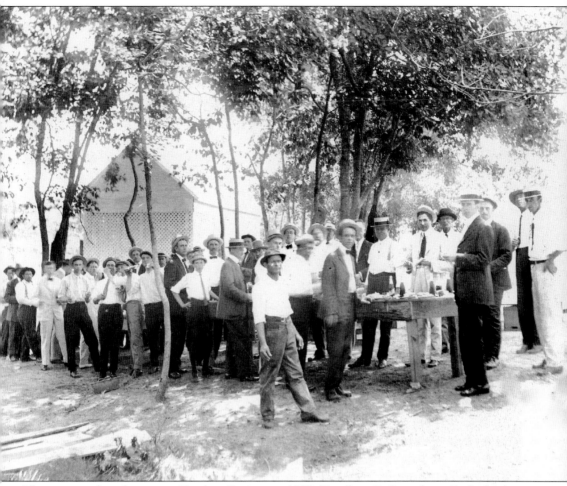

This was a political event at Vandora Springs in 1927. Needham L. Broughton Sr. had a pig cooked for J. Melville Broughton, who was running for the North Carolina Legislature. The cook, Ollie Crocker, is seen walking in the foreground. J. Melville is standing at the end of the table in the dark suit with a hat on and a plate in his left hand. Marvin (left) and Needham Broughton (right) are visible at the far right of the picture (they are not wearing coats). J. Melville Broughton was governor of North Carolina from 1941 to 1945. The springhouse, visible in the background, was torn down many years ago. (Courtesy of Lucile Bryan Stevens.)

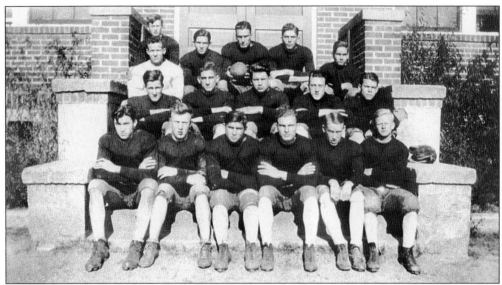

The 1927–1928 Garner High School football team poses in front of Garner High School on Old Garner Road; they are identified, from left to right, as follows: (front row) Horice Bagwell, Thelbert Apple, Fletcher Harper, Raymond Rhodes, Woodrow Broughton, and Charles Allen; (middle row) unidentified, Swede Pool, Lawrence Britt, Graham Purser, Tignal Mitchiner, and unidentified (man in white suit); (back row) Garland Perry, Robert Harper, ? Rhodes, Craven Broughton, and Eugene Buffaloe. (Courtesy of Martha Bryan Liles.)

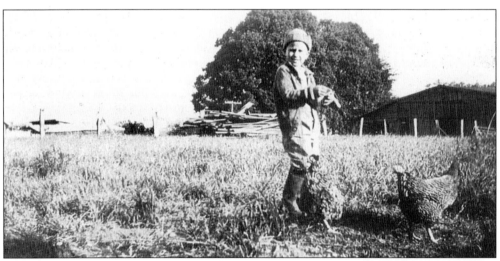

N.L. Broughton Jr. feeds the chickens. The barn to the far right was used to store cottonseed when his father expanded his farming to produce cotton. (Courtesy of Needham L. Broughton family photographs, provided by Lucile Bryan Stevens.)

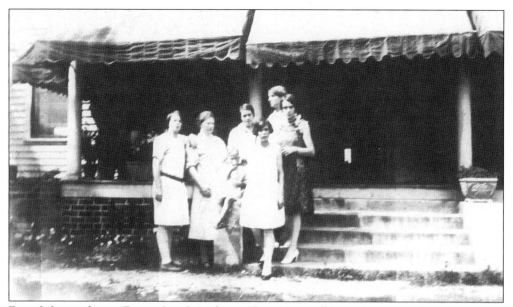

From left to right are Fannie Lee Broughton, Flossie Bagwell Broughton, Needham Broughton Jr., Mrs. Callie Young Wrenn, Mable Wrenn, Ethel Wrenn, and Alma Mae Carroll in front of Flossie Broughton's house on Old Garner Road on July 6, 1929. (Courtesy of the Needham L. Broughton family, provided by Lucile Bryan Stevens.)

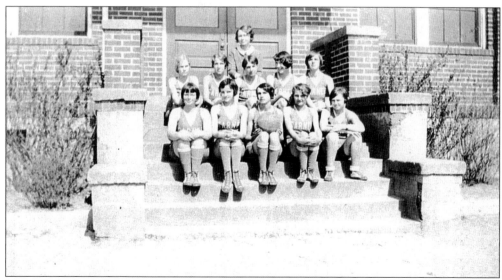

The girls' basketball team at Garner High School, about 1928, are identified, from left to right, as follows: (front row) Fannie Lee Broughton, Thelma Smith, Sallie Mitchiner (holding the ball), Christine Barbour, and Evelyn Wall; (middle row) Grace Bryan, Mabel Mitchiner, Irma Hinnant, Ethel Lee Perdue, and Emma Parrish; (back row) Grace Neathery. (Courtesy of the Needham L. Broughton family, provided by Lucile Bryan Stevens.)

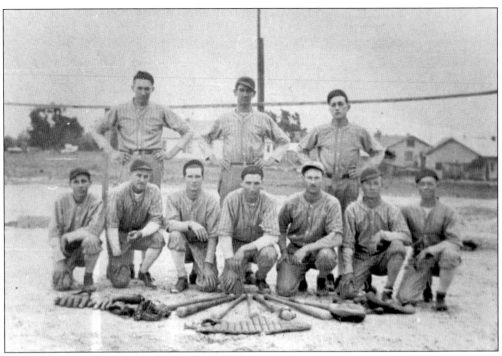

This is the 1929 Garner High School baseball team.

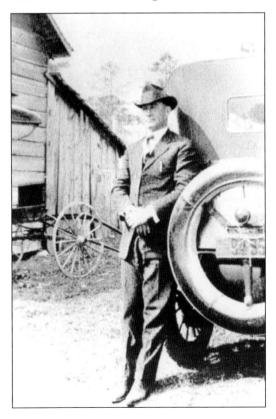

Hubert Bryan poses by his car; notice his buggy in the left. He was an agent at the Garner Depot and a car salesman. He and his wife lived on St. Mary's Street.

# *Three*

# GROWTH OF GARNER THE TOWN

## 1930s to 1960s

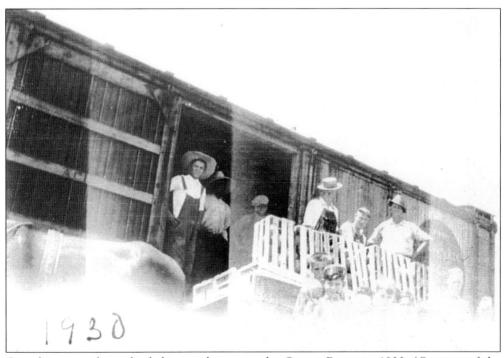

Cantaloupes are being loaded into a boxcar at the Garner Depot in 1930. (Courtesy of the Needham L. Broughton family, provided by Lucile Bryan Stevens.)

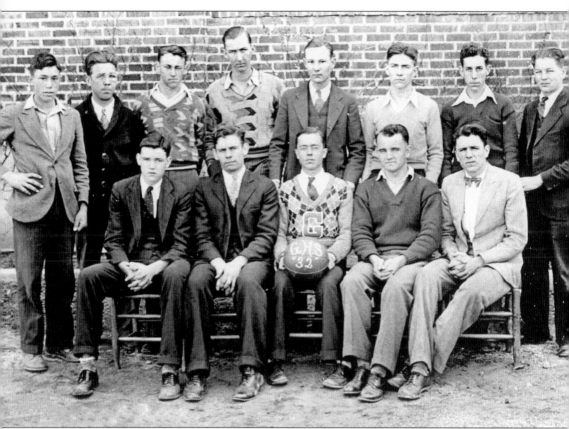

The 1932 Garner basketball team is identified, from left to right, as follows: (front row) Coye Bagwell, Thurman Bagwell, Latt Wall, Laurie Holder, and Carl Lee Bagwell; (back row) Shirley Stancil, Sam Thompson, Dwight Bryan, John Bryan, Woodrow Perry, Jack Howard, Carl Moore, and J.B. Clark (coach).

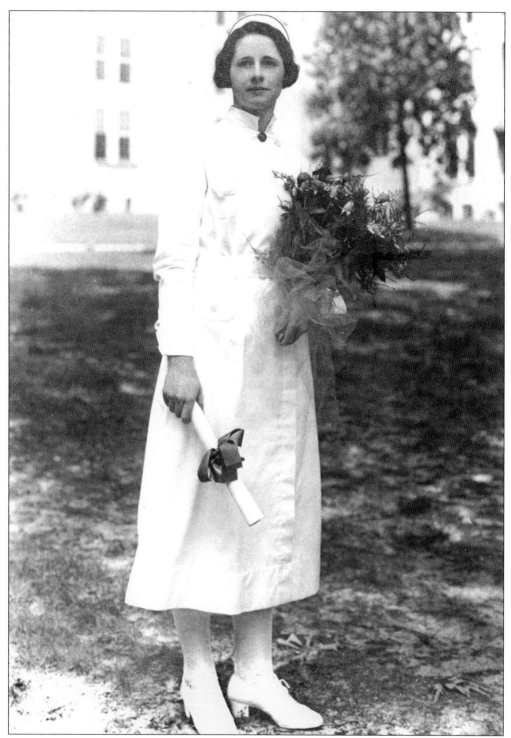

Mary Lee Buffaloe, daughter of Early and Mary Cleveland Blalock Buffaloe, is pictured here at her 1934 graduation from Dorothea Dix's Nursing School. The hospital opened in 1856 as Dix Hill, an institution for the insane. (Courtesy of Kaye Buffaloe Whaley.)

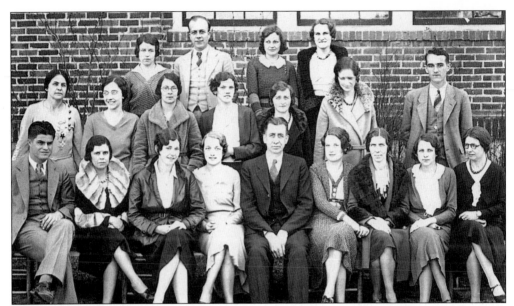

These are the 1932 teachers at Garner High School. The faculty members are, from left to right, as follows: (front row) J.B. Clark (coach), Flora McCormick, Mildred Pipkin, Frances Thompson, L.W. Umstead (principal), ? Brown, Nina Hartsfield, Elizabeth Purnell, and Ethel Buffaloe; (middle row) Mildred Umstead, Nell Barker (secretary to Principal Umstead), Mary Mitchiner, Evelyn "Dollie" Lloyd, Catherine Hockaday, Pauline Anderson, and ? Wilson; (back row) Violet Judd, Wilbur Tew, Eunice Temple, and Margaret Werner. (Courtesy of Barbara Umstead.)

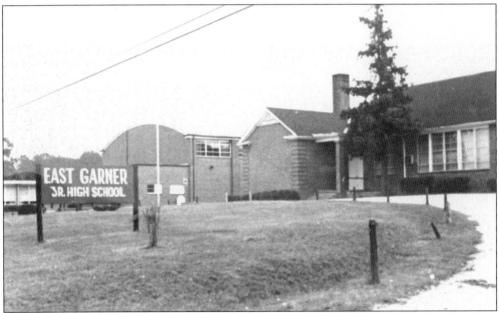

East Garner Junior High School is currently East Garner Middle School and is located on Old Garner Road between Garner and Auburn. When the school was built in 1936, it was Garner Consolidated School. In September 1969, the name changed to East Garner Junior High School.

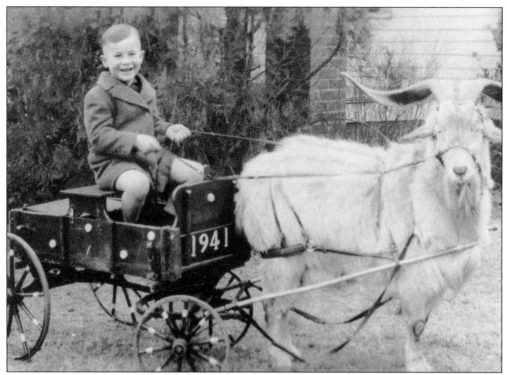

In 1941, a traveling photographer (with his wagon and goat) came through Garner and took a picture of Willis Umstead. (Courtesy of Barbara Umstead.)

This Tom Thumb Wedding (a children's play) was performed at Garner High School in the late 1930s or early 1940s. (Courtesy of Barbara Umstead.)

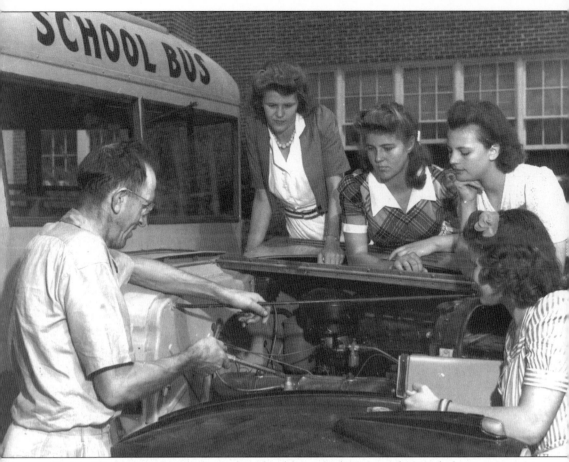

During World War II, girls drove the school buses and were taught simple bus maintenance. They are, from left to right, as follows: (front row) M.F. Roberts (Wake County mechanic) and Mary Kiel Winstead; (back row) Evelyn Weathers, Dorothy Jeffreys, and Lucille Sauls. (Courtesy of North Carolina Department of Archives.)

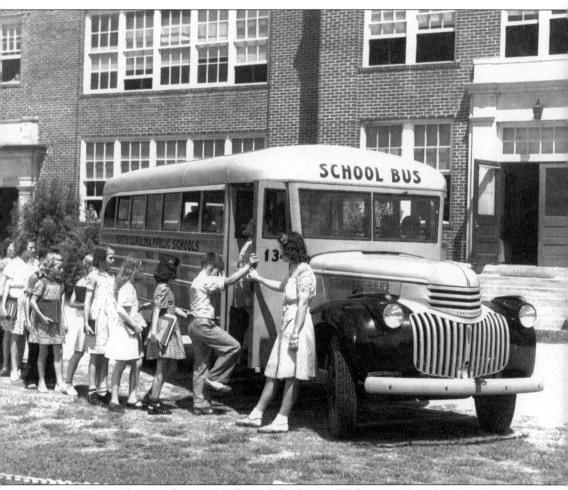

Mary Kiel Winstead is standing at the door of the bus and helping students board a Garner school bus on September 4, 1942. (Courtesy of North Carolina Department of Archives.)

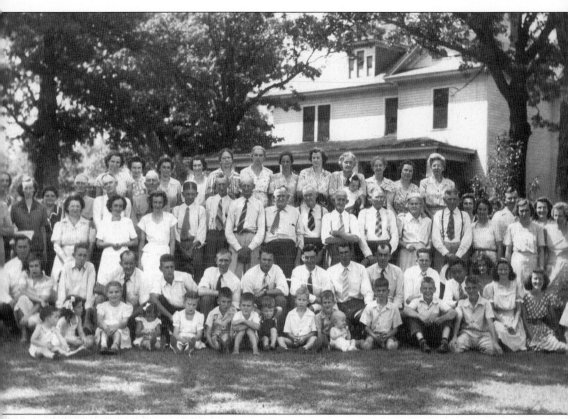

In 1945, the Needham and Sarah Jones Bryan reunion was held at the home of Lon Yeargan on Old Garner Road. From left to right are (first row) Tommy Mack (seated), Phyllis Mack, Betty Jean Bryan, Mary Jo Buffaloe, Kay Buffaloe, Walter Rand III, Anthony Rand, Steve Bryan, Edward Buffaloe, Jimmy Poole, Wayne Poole, Henry Trevathan, Jimmy Bryan, and Bobby Trevathan; (second row) Ryburn Stancil (kneeling), Josie Lee Buffaloe, Joe Bryan, George Bryan, Wade Bryan, Raymond Trevathan, Frank Bryan, P.L. Bryan, Rand Bryan, Leland Poole, Ed Buffaloe, H.H. Chen, Jean Bryan, Joyce Johnson, Josephine Bryan, and Peele Johnson; (third row) Fannie Mae Stancil, Alice Bryan, Dixie Bryan, Jessamine Bryan, Carrie Buffaloe, Lon Yeargan, Henry Poole, Bertie Bryan, Phil Bryan, Lucile Stevens, Paul Bryan, Andrew Bryan, George Bryan, Bunny Bryan, Claude Bryan, Sam Bryan, Dr. J.S. Buffaloe, Agnes Yeargan, Henry Buffaloe, Anne Bryan, Ruth Johnson, Walter Rand, Arnette Bryan, Bea Rand, Flora Yeargan, Cam Yeargan, and Millie Bryan; (fourth row) Clarice Bryan, Catherine Bryan, Mildred Trevathan, Addy Poole, Rose (Mrs. A.J.) Bryan, Rosy (Mrs. George) Bryan, Dulcie Bryan, Frances Mack, Helen Bryan (holding Beth Stevens), Minnie Buffaloe, Edna Earl Buffaloe, and Elizabeth Buffaloe. (Courtesy of Martha Bryan Liles, daughter of Rand and Clarice Holder Bryan.)

The Broughton children, pictured in 1945, from left to right, are Needham Jr., Fannie, and Woodrow "Woody." (Courtesy of Needham L. Broughton family photographs, provided by Lucile Bryan Stevens.)

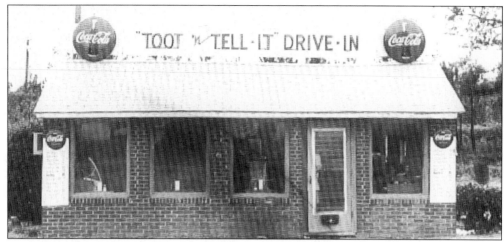

This is a picture of Toot-N-Tell Drive-in, which is still in operation today as a family restaurant. Brookie R. Poole opened Garner's Toot-N-Tell in 1946.

Brookie R. Poole is seen here in his World War I uniform in 1917. (Courtesy of Needham L. Broughton family photographs, provided by Lucile Bryan Stevens.)

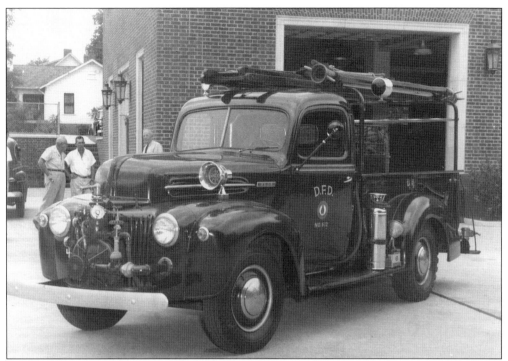

This 1942 Ford was Garner's first firetruck, which was purchased from the Durham Fire Department for $1,000 in 1952. Ralph Whaley and Noel Bryan picked up the truck; this picture was taken at the Durham Fire Department on the day of the pick-up. Garner's fire station was originally located on the west side of Pearl Street, then later relocated to their new brick building at the corner of Main Street and Highway 50. (Courtesy of Ralph Whaley.)

Pictured in 1949, these Garner students are eating watermelon. From left to right are (front row) Tom Davis (wearing hat), Grace Sauls, unidentified (sitting cross-legged), and Magalene Gulley; (back row) Alfred Sauls (kneeling), Dora Gulley, Mable Sauls, and Rosalind Woolard.

The Carroll house on Highway 50 South was built in the late 1940s or early 1950s.

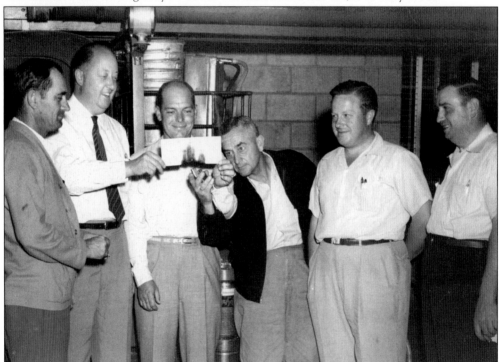

This picture captures a celebratory "note" burning of the Garner Fire Department's satisfied note on its lien on the Pearl Street land and building. Participants included, from left to right, J.R. Collier (mayor of Garner from 1950 to 1954), William E. Jones (president of Garner Fire Department), John O. Moore (director), Noel Bryan (chief), Ralph L. Whaley (director and mayor of Garner from 1957 to 1959), and Joe Buffaloe. (Courtesy of Ralph Whaley.)

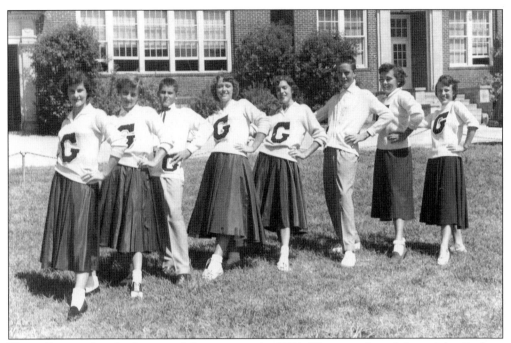

These Garner cheerleaders posed for a picture in 1954. They are, from left to right, Barbara Umstead, Billie Rand, Charles Pearce, Sue Vinson, Yvonne Sauls, Norfleet Jarrell, Phyllis Bryan, and Jane Williams. (Courtesy of Barbara Umstead.)

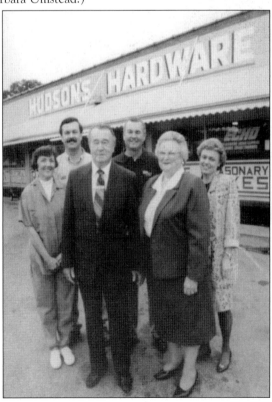

Sam and Anna Hudson purchased this cinderblock building from the Joe Buffaloe estate in 1958 and opened Hudson's Hardware on 50 Highway in Garner. Joe Buffaloe constructed the building in 1951 and operated a grocery store there until about 1957. Pictured in 1994 in front of the old building, from left to right, are (front row) Sam and Anna Hudson; (back row) Pug Hudson (wife of Lee), son Lee Hudson, son Howard Hudson, and Wanda Hudson (wife of Howard). (Courtesy of Lee Hudson.)

A group of Girl Scouts are pictured on the front steps of the Garner Baptist Church on Rand Mill Street about 1954. They are, from left to right, as follows: (first row) Sterling Banks, Mary Marshall Rand, Elaine Johnson, Betty Jean Grissom, and Beth Stevens; (second row) Rodney Ann Dowd, Diane Hatcher, Mary Pat Bryan, Brenda Jones, and Nancy Newberry; (third row) Alice Margaret Collier, Betty Ann Johnson, Nancy Hickman, and unidentified; (fourth row) unidentified, Mary Jo Buffaloe, Margaret Rand, and Geneva Dickson; (fifth row) Sandra Umstead, two unidentified, and Phyllis Bryan. (Courtesy of the Needham L. Broughton family, provided by Lucile Bryan Stevens.)

William "Bill" R. and Elizabeth P. Rand are seen here in 1955. Mr. Rand was the son of H.D. Rand. He was the mayor of Garner in the 1930s or early 1940s (the records burned) and again from 1961 to 1965 (two terms); he was also very active in the Democratic Party and the Garner Methodist Church. Mr. Rand worked in real estate and land development. He enjoyed seeing the ducks and birds that came to the pond behind his house on Perdue Street. (Courtesy of Betty, Margaret, and Mary Marshall, daughters of William and Elizabeth Rand.)

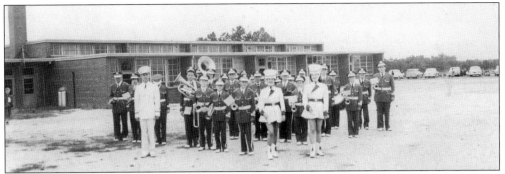

This is the Garner High School's marching band in 1952. (Courtesy of Barbara Umstead.)

From left to right are Edith Humphreys, Jackie Joyner, Brenda Fish, and Mary Pat Bryan in their physical education outfits in front of the Garner High School gymnasium on Avery Street in April 1958. (Courtesy of Kaye Whaley.)

This is the Garner Firemen's Day Parade in 1959. This entry represented Parrish's Beauty Shop on Main Street, which was owned by Nannie Kelly Parrish. (Courtesy of Garner Fire Department.)

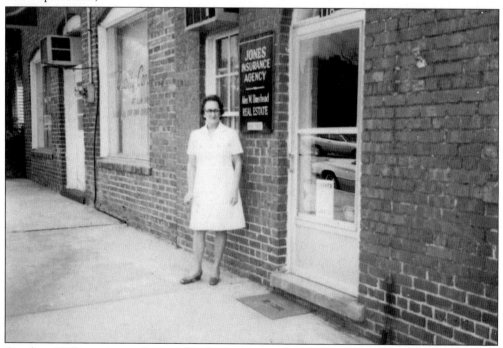

Caroline Williams is standing at the door of Jones Insurance Agency on Main Street about 1961. (Courtesy of Robert M. Williams.)

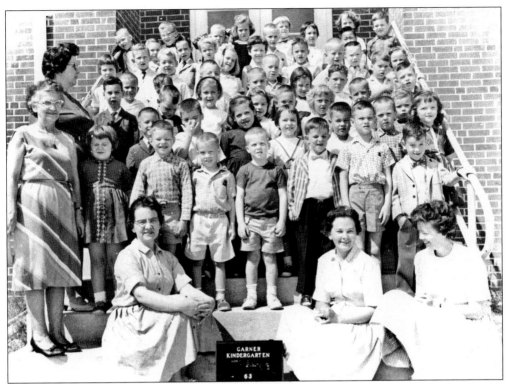

These Garner kindergarten teachers and students pose on the back steps of the Garner United Methodist Church on Oak Circle in 1963. The teachers are, from left to right, as follows: Evelyn Stevens (standing sideways), Portia Banks, unidentified, Sarah Banks, and Carolyn Stevens.

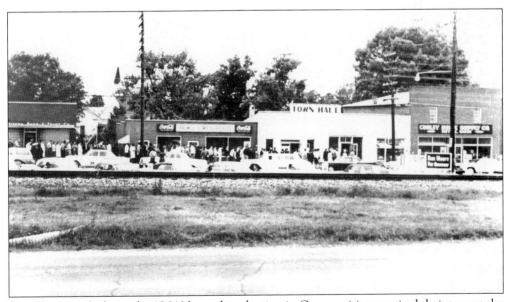

This photograph shows the 1964 November election in Garner; citizens waited their turn at the polls inside Garner's Town Hall, located on Main Street.

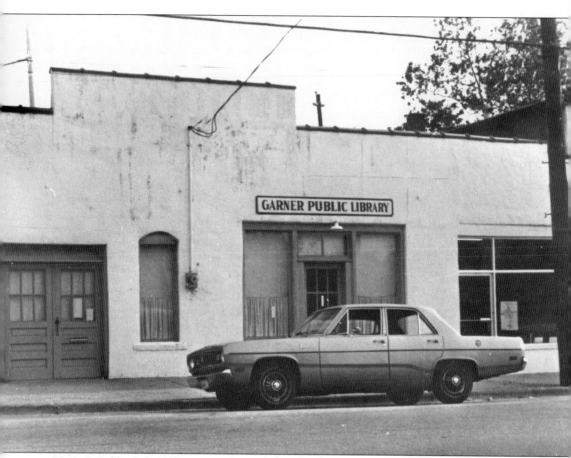

Garner's Public Library began in 1968 on Main Street. The building was the former location of Garner's Town Hall. The library was sponsored by the town's Golden Age and Woman's Club and opened with two sets of bookshelves and a book collection dating back to 1928. Today, Garner's Southeast Regional Library is located off Seventh Avenue beside the Garner Town Hall.

# Four
# Panther Branch and Swift Creek Townships
## 1880s to 1960s

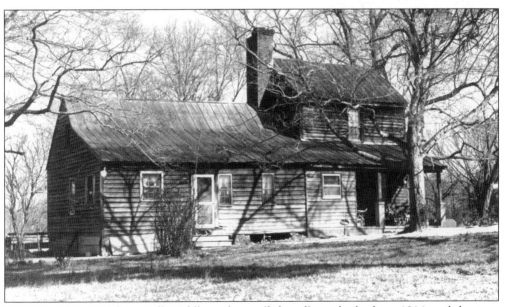

The original part of the Jewell-Middleton house (left end) was built about 1814, and the two-story addition (on the right end of the house) was completed in the 1890s. The house is located off Rand Mill Road on State Road 2728 in Panther Branch township. The fifth generation of this family is currently living in the house. (Courtesy of Ethel Middleton Sauls.)

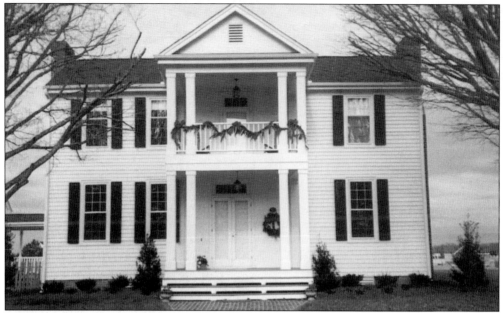

The Burt-Utley house was built between the 1820s and 1830s in the Friendship community near New Hill, North Carolina. The house was originally located where the Shearon Harris Nuclear Power Plant is now. It was moved several times before it came to its final site on Hilltop Needmore Road in Swift Creek township in 1994. Dodson General Contracting restored the house and left a portion of an interior wall exposed, showing several of the original wooden beams with Roman numerals on them. (Courtesy of Roland and Jenny Dodson.)

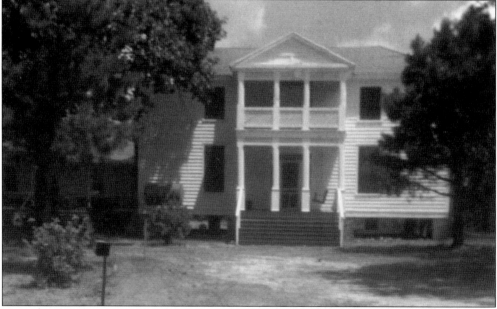

The Adams house, pictured in 1978, is located on Highway 42 in Panther Branch township. Construction began prior to the War between the States and remained incomplete until the war concluded. Sisters Susie and Sophia Adams lived here all their lives with no electricity or indoor baths.

Holland's Methodist Church, in the Panther Branch township, was named in honor of William Holland, believed to have organized Methodist societies in the area. Records from 1807 indicate that Holland bequeathed $400 to be used in the construction of a Methodist meeting house and classroom. (Courtesy of William "Bill" Middleton.)

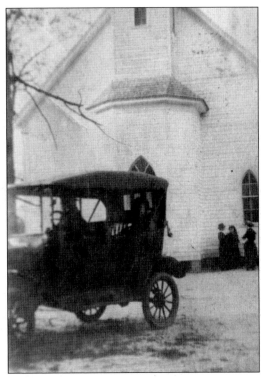

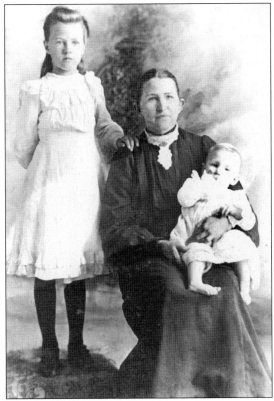

From left to right are Christianna Blalock, Mary Isabell Johnson Blalock (wife of Andrew J. "Jack" Blalock), and Johnny Blalock of Blalock's Crossroads in Panther Branch township in 1906. (Courtesy of Kaye Buffaloe Whaley.)

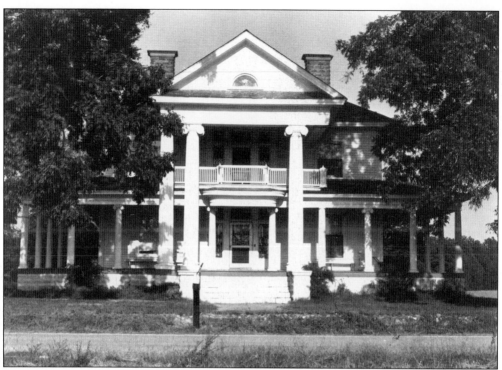

Pictured in 1975 is Dr. Nathan Blalock's house, built in 1910 on Rock Service Station Road in Panther Branch township. (Courtesy of N.C. State of Archives.)

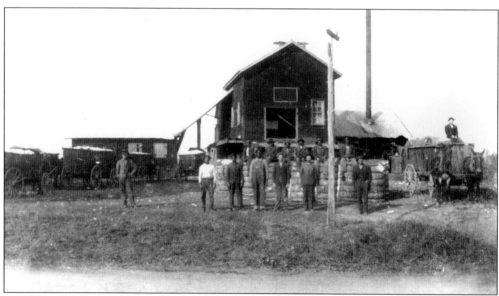

William D. Buffaloe's cotton gin in the early 1900s was located in the Swift Creek township. The gin was located on present-day Highway's 70/401 South, between Tryon Road and Wilmington Street. Cotton, significant in Garner's heritage, was the principal crop farmed in this area and integral to the advancement and progression of Raleigh's neighboring city. (Courtesy of Kaye Buffaloe Whaley.)

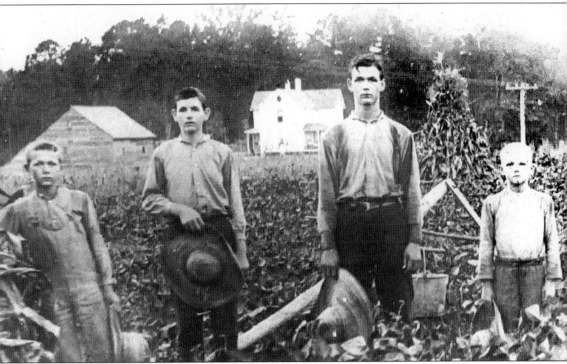

Youth in the fodder field ("fodder" was a term for coarse feed used to feed farm animals) are, from left to right, Cory Britt, Hubert Britt, Ralph Britt, and Gene Britt (children of Z.B. Britt). This photograph was taken at their father's farm in 1910, on Highway 50 South at Nance Hill in Panther Branch township. (Courtesy of Joyce Britt Nobling.)

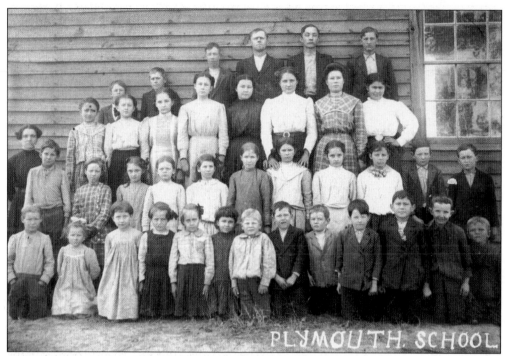

A group of students pose outside Plymouth School in the early 1900s. The school, located on Rock Service Station Road in Panther Branch township, had two rooms—the "Little Room" for grades one through three and the "Big Room" for grades four though seven. The rooms were heated with an iron stove. The building did not have an inside bathroom until 1926. Plymouth merged with Vance School in 1928. The school building was moved to the Davis's farm, and it is currently being used as a farm building. (Courtesy of Gloria Baker.)

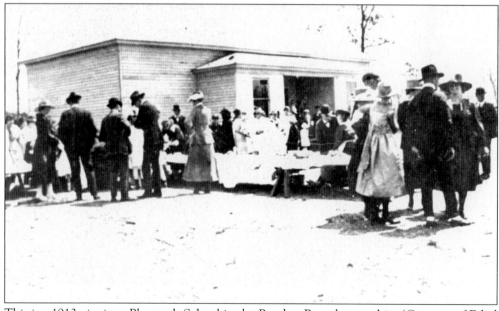

This is a 1913 picnic at Plymouth School in the Panther Branch township. (Courtesy of Ethel Middleton Sauls.)

In 1916, David Massey (with his toy rifle) and Frances Massey (with her doll) are standing in front of the Jewell-Middleton house on State Road 2728 in Panther Branch township. Their parents were Charlie and Lizzie Massey. (Courtesy of Bobby Creech.)

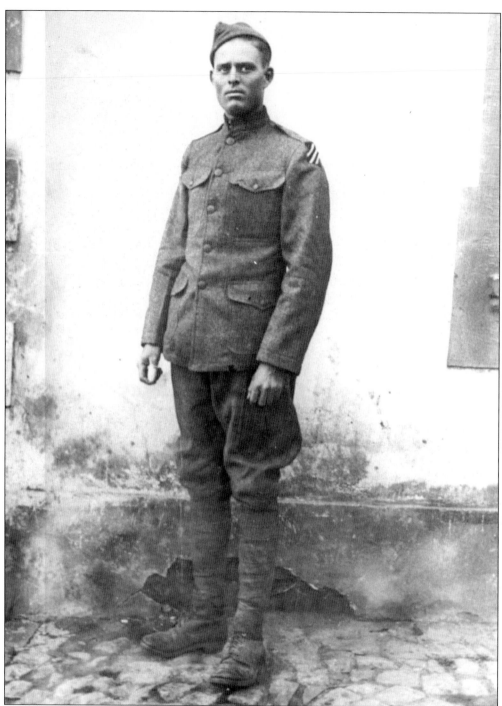

Mallie Andrew Penny was a private in Battery E-76FA, 3rd Division in World War I. He was stationed in Germany and France. This picture was made while in France. After he returned home to Panther Branch township, he worked as a tobacco farmer and also grew cotton. Mallie and his wife, Ida Carroll Penny, were active members of Mt. Zion Methodist Church. (Courtesy of Lois Humphries Gainey.)

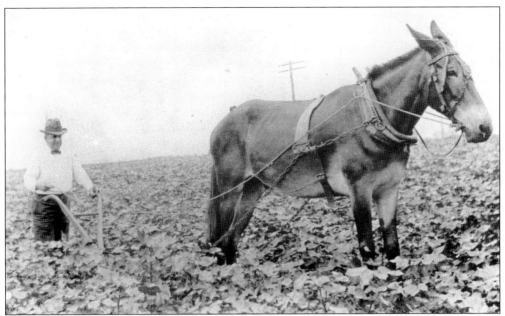

Z. Bunyon Britt is seen here in his cotton field. Britt was an active member in the Wake County Farmers Association. (Courtesy of Joyce Britt Nobling.)

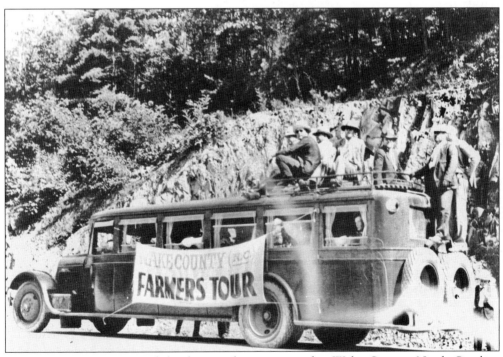

Z. Bunyon Britt was one of the farmers that went on this Wake County, North Carolina Farmers Tour, which took place in the late 1920s. (Courtesy of Joyce Britt Nobling.)

Turner School, established near the Herbert Sauls's farm as a private school, became a "common school" in the 1850s. In this *c.* 1920 picture, the school is being painted. Notice the Job P. Wyatt & Sons Co. advertisement; the company operated in Raleigh on Wilmington Street and eventually formed Wyatt Quarles Seed Company. The Wyatt name is familiar to Garner residents, as the seed company continues to flourish and operate in Garner off Highway 70 West.

Pictured *c.* 1910, Turner School students are identified, from left to right, as follows: (first row) Ella Smith, Lydia Smith, William Turner, Annie Bell Williams, Nellie Johnson, Mary Louise Turner, Miss Henri Tisdale (teacher), Tommy Britt, Milton Johnson, and Robert Stevens; (second row) Grace Markham, Mamie Stevens, Eva Jones, Walter Johnson, Joe Stevens, Ira Perry, Lucy Jones, Amelia Turner, John Stevens, Peyton Middleton, Emmitt Turner, Sandle Sauls, Ernest Sauls, and Sam Sauls; (third row) Burke Carroll, Bob Sauls, David Turner, Earl Brady, Jimmy Jones, Troy Britt, Cary Britt, LeMay Turner, Paul Stevens, Sherwood Smith, Hudson Sauls, and Lilly Markham (fourth row) Bertha Smith, Miss Fay Leach (teacher), Lina Middleton, Minnie Stevens, Clyde Britt, Ethel Middleton, Pearl Britt, Lilly Jones, Mary Sauls, Minda Smith, Howard Turner, and Delphia Johnson. (Courtesy of Ethel Middleton Sauls.)

Pictured at Christiana Jones's farm in Panther Branch township in 1926 are, from left to right, the following: (front row) Earl Buffaloe and Watson Jones; (middle row) Estelle Jones, Kathleen Buffaloe, and Georgia Jones; (back row) Wilfred "Sunshine" Buffaloe, K.T. Jones, and Isabelle Buffaloe. Mary Lee Buffaloe made the suits that Earl Buffaloe and Watson Jones are wearing. (Courtesy of Kaye Buffaloe Whaley.)

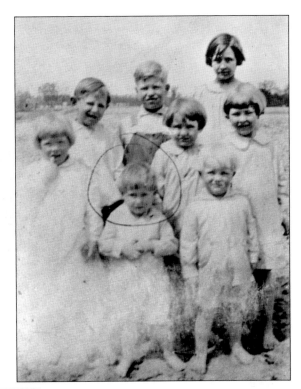

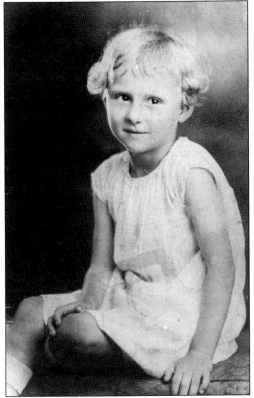

Margaret Penny Humphries is photographed here in 1927 at the age of six. Her parents were Mallie and Ida Penny of Panther Branch township. Margaret married Elbert Humphries and lives in Garner. (Courtesy of Lois Humphries Gainey.)

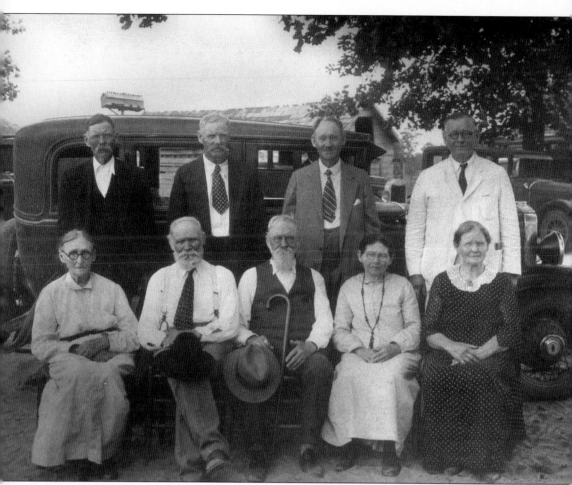

From left to right are the following: (front row) Lemon "Lem" Blalock (Adams), William "Bill" Blalock, Andrew Jackson "Jack" Blalock, Annie Blalock (Adams), and Sooner Blalock (Ogburn); (back row) Joseph "Joe" Blalock, Hugh "Peace" Ryas Blalock, Dr. Nathan Blalock, and Rev. Alfred Blalock. Their parents were Hugh and Christiana "China" Matthews Blalock. Pictured prior to 1937, these brothers and sisters grew up at Blalock's Crossroad in Panther Branch township. (Courtesy of Kaye Buffaloe Whaley.)